IMAGES
of America

LONG BEACH

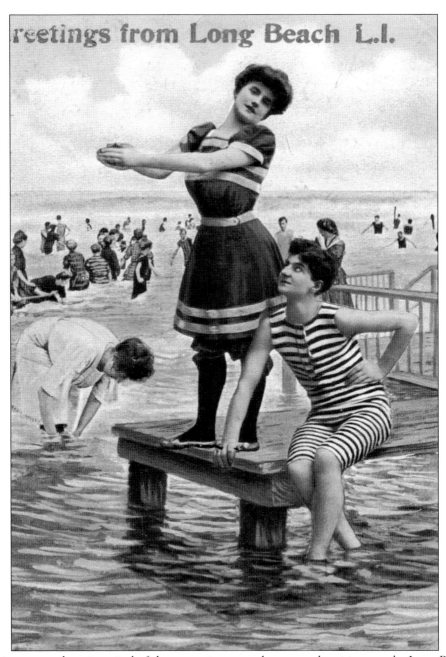

reetings from Long Beach L.I.

The image seen here is typical of the souvenir postcards sent out by visitors to the Long Beach Hotel in the late 19th century. The welcoming beauty in fashionable bathing attire is poised to join other seaside frolickers in the waters of the Atlantic Ocean along the south shore of Long Beach. (Herman Druckman.)

ON THE COVER: The Nassau Hotel stands to the left in this early-20th-century Ambrose Fowler photograph of promenaders strolling the Long Beach boardwalk. Fowler, an eminent photographer of his time, was noted for his photo postcards depicting Long Beach scenes.

IMAGES
of America

LONG BEACH

Roberta Fiore, Carole Shahda Geraci, and Dave Roochvarg
for the Long Beach Historical and Preservation Society

ARCADIA
PUBLISHING

Published by Arcadia Publishing
Charleston, South Carolina

Printed in the United States of America

Library of Congress Control Number: 2009936163

For all general information contact Arcadia Publishing at:
Telephone 843-853-2070
Fax 843-853-0044
E-mail sales@arcadiapublishing.com
For customer service and orders:
Toll-Free 1-888-313-2665

Visit us on the Internet at www.arcadiapublishing.com

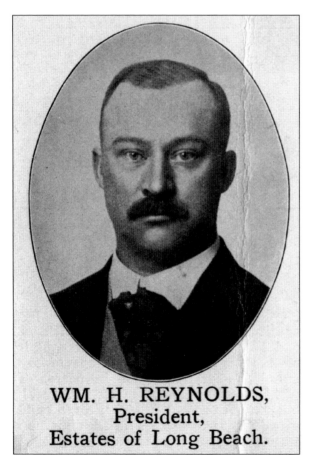

**WM. H. REYNOLDS,
President,
Estates of Long Beach.**

Long Beach was conceived in 1906 by Sen. William H. Reynolds. In his youthful and determined vision, he saw what Long Beach could become—an unrivaled seaside resort for those who wished to see an elegant, healthful environment. He dreamed and built the structures of community captured in the images included in this book. What is seen herein and in Long Beach today are in essence the results of his foresight, real estate saavy, and showmanship.

CONTENTS

ACKNOWLEDGMENTS

This book came into being with the cooperation of our colleagues, the Trustees of the Long Beach Historical and Preservation Society, who allowed us unlimited use of the Long Beach Historical Museum's archived materials. Our thanks to the society's members whose names appear with their contributions and to those whose photographs are not included in this edition but have enriched the museum's archive. Unless otherwise noted, photographs are from the Long Beach Historical Museum's archive or the collections of the authors. We especially wish to express our wholehearted appreciation for the incredibly organized resources provided by Betty Beller, society trustee and volunteer archivist. The creation of this pictorial history of Long Beach is also attributable to the photographs and resource assistance of the reference librarians at the Long Beach Public Library (LBPL). We are grateful to Mark McCarthy for granting us unlimited access to the Lola's Restaurant collection.

INTRODUCTION

Long Beach, the City by the Sea, sits atop a barrier island parallel to the southern coast of Long Island. It is surrounded by open water, completely detached from the mainland, and is literally a city "five miles out to sea." Henry Hudson sailed past in 1609 and is said to have observed "a long bar of glistening white sand, planed smooth by the wind." The Great Sand Beach, so named by colonial nautical chart makers, had salt marshes in its northern waters and was cut by Luces Inlet on its eastern tip, Rockaway Inlet at its western edge, and to this day has the great Atlantic Ocean as its southern border.

Accessible only by boat, the island was visited by Native Americans of the Algonquin tribe mainly during the summer months. Attracted by the rich resource of fowl and sea life in the ocean and marshes, the Rockaway tribesmen erected longhouses for their seasonal stay on the white sand beach. Hunting, clamming, whaling, and wampum seashell gathering were the first occupations on these shores.

For more than 100 years, this sandbar called Long Beach has been the scene of change—not a very unusual happenstance for most places, but for Long Beach the developmental stages have been phenomenal in such a short period. As an 18th-century baymen's enclave, Long Beach, with its rich flora and fauna surrounds, contributed greatly to the livelihood of those men. In 1878, utilizing post Civil War technology, a syndicate leased a portion of our barrier beach as a railroad terminus and in 1880 built and later abandoned a world-class seaside resort hotel.

In 1906, a Brooklyn syndicate, led by Sen. William Reynolds, purchased the hotel and railroad lease. Two years later, they dredged the marshland waters and "filled-in" the sandbar, thereby raising its topography by 9 feet and creating a rectilinear design for a planned community. The executed plan was perfectly engineered to accommodate The Estates of Long Beach—large stucco, red tiled-roof homes spaciously built according to covenants on newly created building lots. Situated on red-bricked streets, these international style houses were bordered on the Atlantic Ocean side by a more than 2-mile new boardwalk built on concrete pillars. Reynolds created a publicity coup by bringing elephants from his Coney Island Dreamland to swing some timbers, thus leading to what is believed by many even today—elephants built the boardwalk. To replace the Long Beach Hotel, which burned-to-the-ground in 1907, Reynolds constructed the Nassau Hotel in 1908 and the National Bathing Pavilion for daily visitors who arrived on the Long Island Railroad. The Casino, at the east end of the boardwalk, drew the automobile crowd, including those who wished to be instructed in the tango by Rudolf Valentino. Among the hotels now lining the boardwalk was the Trouville—their very elegant Turkish dining room provided an exquisite setting for lush dining pleasures.

The next phase of development occurred when World War I entered the scene, and for a time the island was mainly utilized by the military. The Nassau Hotel served as a military hospital, and soldiers marched on the boardwalk as the music pavilion that once echoed with Strauss now heard Sousa. Their postwar legacy was the Walks—a neighborhood of lanes with solely pedestrian

access. By war's end, the westerly portion of Long Beach had become a seasonal community adopted by summer residents who rented or bought the new Bossert bungalows built along the state-and-month-named streets and avenues, the order of which remains a puzzle to this day.

The Roaring Twenties and prohibition arrived, and Long Beach became a safe haven for rumrunners and a playground for celebrities. Flo Zeigfeld and his "scantily clad girls" frolicked on the beach to the chagrin of more staid residents. Twenty-eight speakeasies thrived along West Beech Street—one, Shine's, remains today. Several villas even housed gambling emporiums. Long Beach was again caught in a sea of change. Bankruptcy hit Reynolds' Estates of Long Beach, and real estate auctions became the "play of the day." Undaunted, Mayor Reynolds took on new engineering challenges including the canals and the grandiose Lido Hotel. At the foot of the Lido, a new neighborhood was created on narrow plots. These sandcastle-type homes with built-in garages and high stoop entrances came to be called "The President Streets," although not many were so named.

By the 1930s, Long Beach had evolved into a year-round community of families. Family-owned businesses prevailed along Park Street, as Long Beach was perceived as a healthy environment in which to raise children. The first school was housed in a room at the Nassau Hotel. The boardwalk became less flamboyant and more attuned to family life. The transformation from the elite to working class first generation citizens removed the last vestiges of the planned community's rules against ethnic diversity.

Its location, often cited as being "5 miles out to sea," makes Long Beach vulnerable to nature's harsh attacks. Although ships are no longer wrecked onto its shore, each decade has experienced the havoc played by hurricanes—most infamous of which is the hurricane of 1938. The annals of Long Beach history report infamy of another sort, that which is brought about by man's cruelty to man. A still unsolved mystery lies in the story of Starr Faithfull, whose body washed up onto the beach in 1932. And the most notorious story of 1939 was the assassination of Mayor Edwards by the very man who was assigned to protect him.

Long Beach saw many sons and daughters off to war as it joined the World War II home front effort. The luxurious Lido Hotel now served the U.S. Navy as a post through which sailors were mustered both in and out of service. The postwar 1950s brought gaiety again to the boardwalk but in a much different style than that of its early years. Beauty and baby pageants, arcades and amusements, and refreshment counters were now the attractions. However, habitation and infrastructure on the barrier beach had passed the 50-year mark and was beginning to show wear. By the 1960s and 1970s, absentee landlords, air conditioning, and the airplane had taken their toll on this small city by the sea. One solution that was embraced to generate capital and increase the tax base was to build up! More taxpayers could reside in one high rise than on one city block. Not considered was the domino effect, which included older dwellings tumbling into decline, necessitating unfavorable solutions. A new neighborhood of apartment buildings began to line the northern edge of the boardwalk

The 1980s saw a renaissance that continues through today. Every lot has been bought, and, not unlike the 1950s, Long Beach has chosen to go higher and higher on those lots of sand. All of the natural resources are once again becoming valued. Today volleyball, surfing, walking, cycling, and outdoor concerts are favorite play activities. In the 21st century, Long Beach still welcomes the daily train arrival of thousands of visitors who come to seek the pleasure of its restaurants, upscale Allegria hotel, boardwalk, and, of course, its unspoiled beach park.

One

THE RAILROAD
RESORT

In 1878, a syndicate leased a portion of our barrier beach to build a railroad terminus and a resort hotel. In 1880, record breaking construction was completed in 90 days on the Long Beach Hotel. This opulent hotel brought Greater New York's first awareness of our barrier island as a healthful place reachable by railroad from New York City as well as by boat.

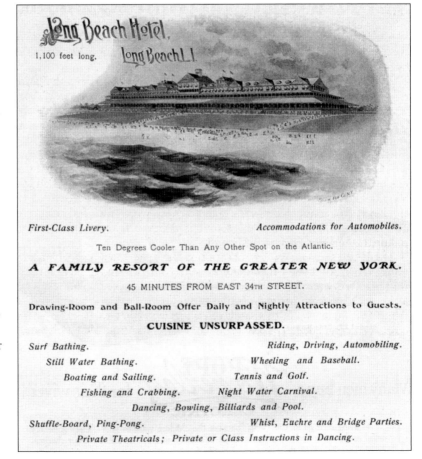

Long Beach Hotel, Long Beach L.I.

1,100 feet long.

First-Class Livery. Accommodations for Automobiles.

Ten Degrees Cooler Than Any Other Spot on the Atlantic.

A FAMILY RESORT OF THE GREATER NEW YORK.

45 MINUTES FROM EAST 34TH STREET.

Drawing-Room and Ball-Room Offer Daily and Nightly Attractions to Guests.

CUISINE UNSURPASSED.

Surf Bathing. Riding, Driving, Automobiling.
 Still Water Bathing. Wheeling and Baseball.
 Boating and Sailing. Tennis and Golf.
 Fishing and Crabbing. Night Water Carnival.
 Dancing, Bowling, Billiards and Pool.
Shuffle-Board, Ping-Pong. Whist, Euchre and Bridge Parties.
 Private Theatricals; Private or Class Instructions in Dancing.

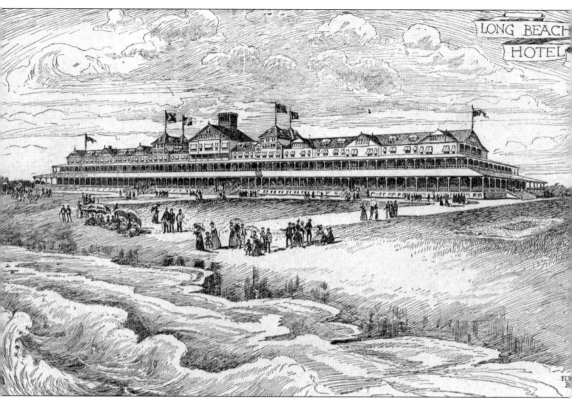

The 1880 Long Beach Hotel enjoyed the distinction of being the largest seaside hotel in the world. The sketch seen here illustrates the architectural beauty of this superstructure built in the Queen Anne style with low roofs and projecting gables, offering the perfect setting for every form of adapted Edwardian entertainment. The building was 1,100 feet long and 150 feet wide, surrounded by a spacious piazza. The roofs, gables, tower, and curtain walls were covered with nearly a million redwood shingles. The entire first floor could be thrown open to the ocean air from front to rear by a simple raising of the glass windows on both sides. A magnificent promenade just 3 feet lower than the first floor was created by a wide, covered terrace running around the south, east, and west sides. Hotel guests enjoyed secluded privacy on the second floor with its smaller porches, dining rooms, parlors, and select bedrooms. The two top floors provided additional sleeping chambers and baths. Broad flights of stairs led to the second floor, while two commodious elevators afforded easy access to the different floors.

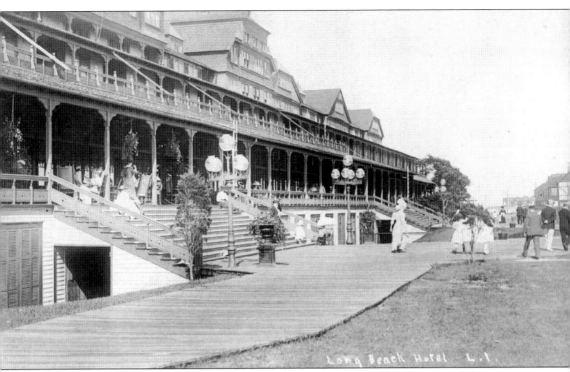

This view of the seaside facade of the great 1880 Long Beach Hotel informs us of the ornate, lamp-flanked sweeping stairway entrances to the incredibly long veranda that was topped by a full length of smaller porches. Guests seated on the veranda were able to comfortably enjoy the concert music that would float from the music pavilion located directly across from this side of the hotel. Its elegance was further enhanced by the rich tones of green and gold paint decoratively applied to the redwood posts supporting the girders of the second floor. It served as a colorful and easily recognizable landmark for ocean vessels sailing to and from New York Harbor. A track entered the building at the northeast corner under the north porch to carry supplies to the basement where the working departments were located around the hotel's large chimney shaft. Seen below the staircases are entrances to the basement through which the services for outdoor activities were easily facilitated. (Courtesy of Grant Geidel.)

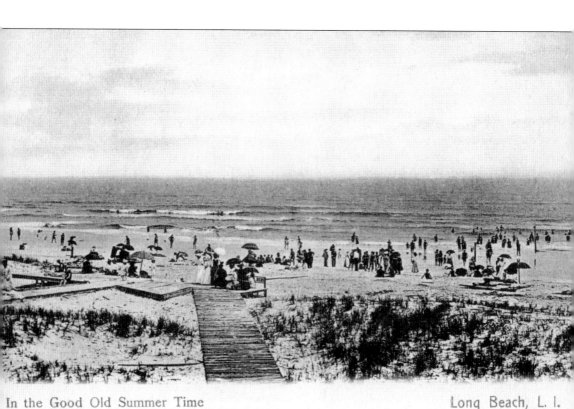

In the Good Old Summer Time Long Beach, L. I.

In the style of seaside hotels of the time, such as Austin Corbin's Oriental Hotel in Brooklyn's Manhattan Beach, the first Long Beach boardwalk ran flat on the sand the length of the hotel property and led to other buildings in the complex as well as to the bathing beach. The bathing pavilion included 200 special rooms for guests of the hotel, 550 public ones and about 200 additional ones for ladies exclusively. In each section, a big fresh water shower drew upon the water pumped 23,000 feet to the hotel from a reservoir on the line of the railroad near East Rockaway. No saloons or other establishments were allowed on the beach. Water and sewage problems eventually contributed to the hotel's downfall and to pollution of the bay. (Courtesy of Herman Druckman.)

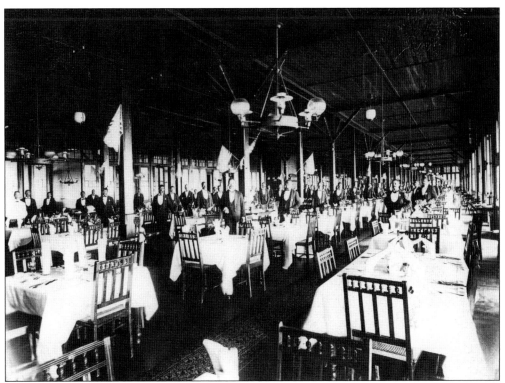

The 1,000-chair restaurant was known as one of the choicest in the country for the quality of the dining experience it offered. The *carte de jour* was printed on heavy card stock, elegantly tinted, and contained 16 courses, each devised to tempt and please the palates of epicures and bon vivants. Located at the center of the decorated wood first floor of the 1880 hotel was a 175-foot-by-80-foot refreshment room with the restaurant to the west and a café to the east. Also on the first floor were all the serving rooms necessary to wait upon and serve 5,000 people, all clamoring to be waited upon at the same time. The restaurant and café were surrounded by open porches that were 50 feet wide, all of which could be made into one by folding back the glass partitions that separated them. (Right, courtesy of Mark McCarthy.)

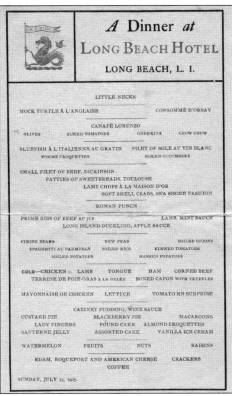

A Dinner *at*
LONG BEACH HOTEL
LONG BEACH, L. I.

LITTLE NECKS

MOCK TURTLE À L'ANGLAISE CONSOMMÉ D'ORSAY

CANAPÉ LORENZO

OLIVES SLICED TOMATOES GHERKINS CHOW CHOW

BLUEFISH À L'ITALIENNE AU GRATIN FILET OF SOLE AU VIN BLANC
POMME CROQUETTES SLICED CUCUMBERS

SMALL FILET OF BEEF, DICKINSON
PATTIES OF SWEETBREADS, TOULOUSE
LAMB CHOPS À LA MAISON D'OR
SOFT SHELL CRABS, SEA SHORE FASHION

ROMAN PUNCH

PRIME RIBS OF BEEF AU JUS LAMB, MINT SAUCE
LONG ISLAND DUCKLING, APPLE SAUCE

STRING BEANS NEW PEAS BOILED ONIONS
SPAGHETTI AU PARMESAN BOILED RICE STEWED TOMATOES
BOILED POTATOES MASHED POTATOES

COLD—CHICKEN LAMB TONGUE HAM CORNED BEEF
TERRINE DE FOIE-GRAS À LA GELÉE BONED CAPON WITH TRUFFLES

MAYONNAISE OF CHICKEN LETTUCE TOMATO EN SURPRISE

CABINET PUDDING, WINE SAUCE
CUSTARD PIE BLACKBERRY PIE MACAROONS
LADY FINGERS POUND CAKE ALMOND CROQUETTES
SAUTERNE JELLY ASSORTED CAKE VANILLA ICE CREAM

WATERMELON FRUITS NUTS RAISINS

EDAM, ROQUEFORT AND AMERICAN CHEESE CRACKERS
COFFEE

SUNDAY, JULY 23, 1905.

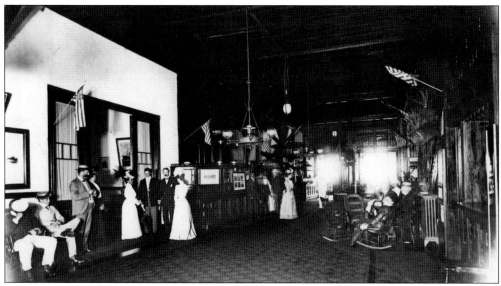

The late-19th-century lobby of the Long Beach Hotel incorporated into its furnishings such "modern" conveniences as a tickertape machine, telegraph, telephones, and steam-heated radiators. In 1881, Long Beach's first post office was established here in the lobby. At the time, Long Beach was a part of Queens County, as Nassau County was not created until 1899, thus qualifying the Long Beach Post Office as being one of the oldest in Nassau. The lobby was but one of the convenient public meeting areas on the first floor of the hotel. The café as seen here was located on the eastern side of the hotel and along with the wine rooms and several private dining rooms provided optional gastronomical experiences. Also to be found on the first floor was a billiard room for the gentlemen while their ladies enjoyed the comforts of the retiring rooms or the writing salons.

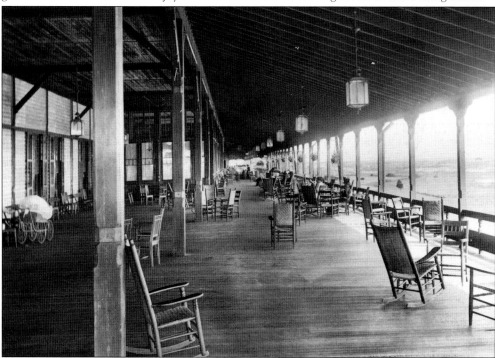

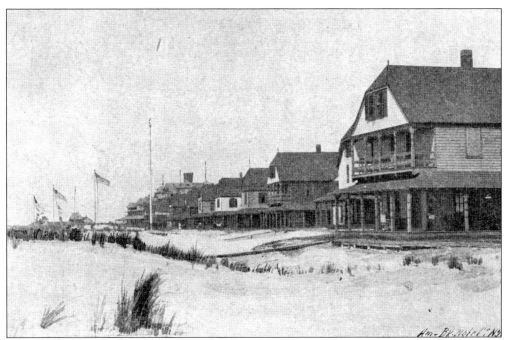

East of the hotel was a row of 21 cottages, which, like the hotel, were built and furnished in the Queen Anne style. They were handsomely built and sturdily constructed. Each was two stories and contained nine large rooms, a parlor, and hall extending the full length of the sea front, and French doors inlaid in wood. Upstairs were five large bedrooms with baths.

The hotel cottages were on a sandy bluff 500 feet from the surf and lined with a private beach. They were rented by the season as fast as they were built for about $600 to well-known and wealthy bankers, politicians, and financiers, many of whom would arrive by rail in their private parlor cars, which would be held on a siding behind the hotel.

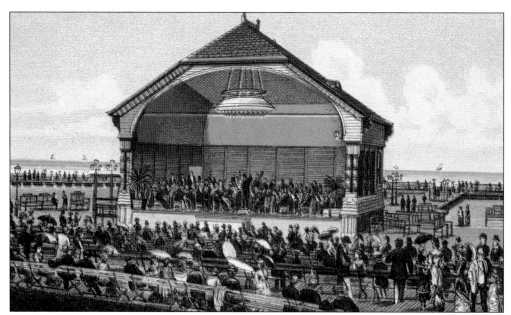

Directly in front of the hotel was a large, light music stand in which noted musicians and 60-piece orchestras from as far away as Germany would perform. The compositions of Strauss and Wagner would float from the pianoforte or pump organ through the summer air, reaching hotel and cottage guests seated in the comfort of the verandas as well as in front of the pavilion.

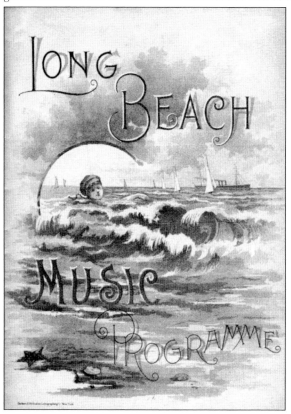

Afternoon and evening programs included musical and dance performances, pantomimes, prestidigitation acts, as well as tableau vivant scenes such as *Mrs. Jarley's Wax Works,* which were brought to the stage and spoofed historic figures. On occasion, hotel guests would put on a performance to benefit the musicians who had entertained them throughout the season. The illustrated music program was created for the pleasure of the hotel's guests on Saturday evening, August 20, 1892.

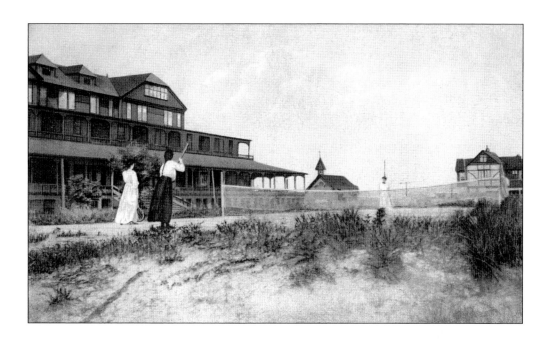

Free from the crowds of transient visitors found at other seaside resorts such as Coney Island, the Long Beach Hotel stood as a charming retreat for tired and heated New Yorkers. Here they could enjoy the cool breeze and refreshing surf while participating in leisurely activities. In addition to ladies' and gents' billiards, other amusements provided for the pleasure of guests were the genteel sports of kite flying, badminton, and croquet. Grace Chapel, the first church in Long Beach, is seen in the center of the photograph above. The hotel's management team quickly recognized the growing popularity of baseball and provided a fully equipped, albeit small, diamond, for the athletic pleasure of their guests. Weekend guests soon discovered though that there was one proviso—baseball could not be played on the Sabbath.

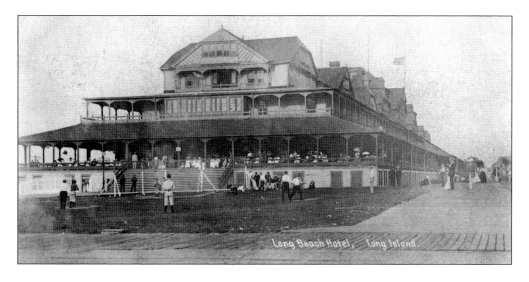

In 1882, Oscar Wilde was a guest lecturer at the Long Beach Hotel where he presented informal lectures in the dining room. This sketch, entitled *"A Scene at Long Beach, the New and Popular Resort,"* appeared in Frank Leslie's weekly magazine on August 12, 1882. It was drawn by a staff artist as an illustration of an article about Wilde's visit to New York. Wilde, in bathing attire, stands in the center on the beach accompanied by Sam Ward, his New York agent. While at the hotel, Wilde spent a day with Alice Pike Barney and her daughter, Natalie. He persuaded Alice to take an early morning swim with him during which she sustained an injury to her foot and embarrassedly had to be carried back to the hotel. This did not negate Alice's admiration for Wilde, and she took heed of his advice to pursue a career as an artist despite her husband's disapproval. This chance meeting at the 1880 Long Beach Hotel gave us a leading American painter and generous patron of the arts, Alice Pike Barney.

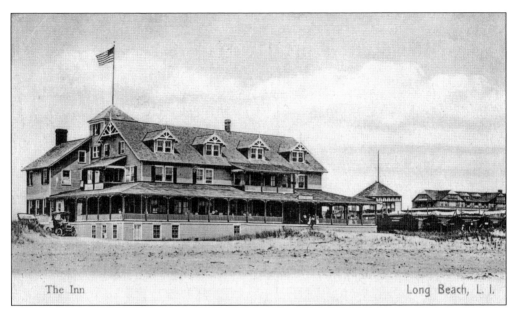

The Inn Long Beach, L. I.

As the automobile became a popular mode of transportation the exclusiveness of hotel accommodations was adapted to meet the needs of the new autoists. The Inn, located just west of the Long Beach Hotel, was a welcome new hostelry, for it was there that along with its touring car guests, chauffeurs and their vehicles were readily accommodated. Like the Long Beach Hotel it was built in the Queen Anne style with a deep veranda on the beachside and second-floor private porches. In 1908–1909, Senator Reynolds had it moved to a site on Long Beach Boulevard to make room for the facilities of his new ventures along the boardwalk. Following the move the name The Inn was changed to the Hotel Abell, for its owner, James M. Abell, who later served as the Long Beach Tax Assessor and Real Estate Board President. (Above, courtesy of Grant Geidel.)

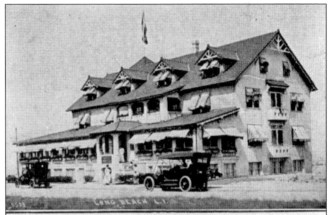

19

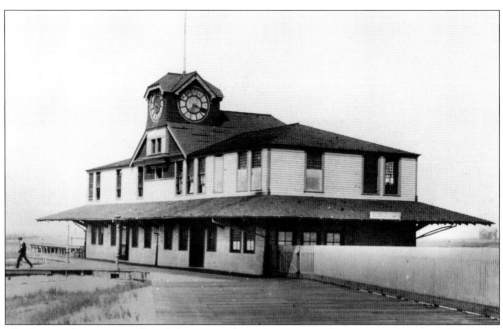

The late-19th-century railroad depot stood at what is now the corner of Park and Edwards Boulevard. The station building was a two story rambling Queen Anne style wood structure topped by a multi-shaped shingled glass four-sided clock tower—a presage perhaps of future Long Beach City Hall clock towers. Its waiting room and an outdoor pavilion provided respite for passengers traveling by train across the marshes over a wooden trestle bridge to and from New York City. A large storage tank in a tower to its west provided the water to create the steam that powered the locomotives. The depot's location, a short distance behind the 1880 hotel, allowed passengers to walk to the hotel or a bit further to board the Marine Railway that ran along the beachside and carried passengers to the hotel's cottages or to Point Lookout at the eastern end of Long Beach Island.

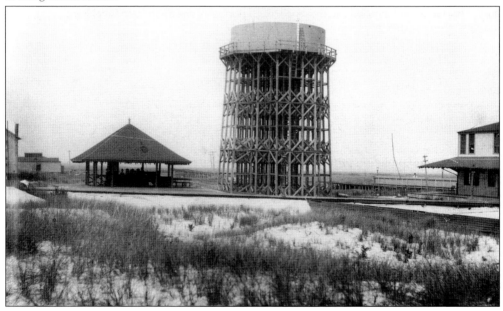

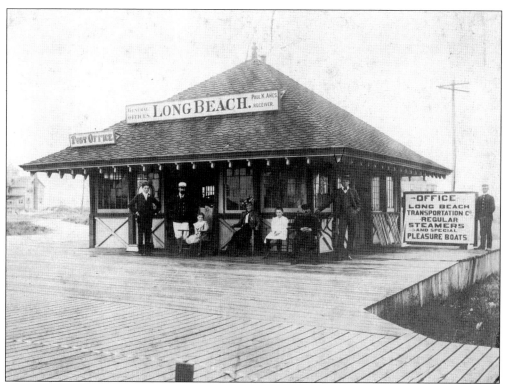

Paul K. Ames established the 1890 office of the Long Beach Transportation Company when he was appointed receiver in an attempt to revitalize the resort following the failure of the 1880 hotel. People and supplies could also arrive at Long Beach via steamer or pleasure boats with arrangements made by LBTC. The post office, which had previously been housed at the Long Beach Hotel, was relocated to this building. Ames was largely responsible for the first macadamized road constructed on the island enabling the touring crowd to arrive by car. The vehicles were not permitted to park beyond the canopied wood portals of the revitalized hotel but could be left standing along a fence bordering the tennis courts.

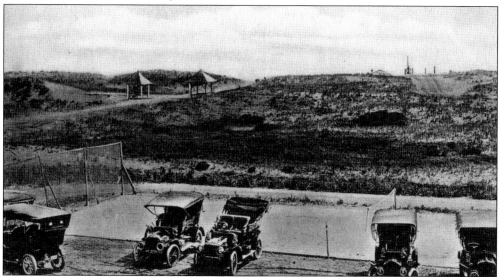

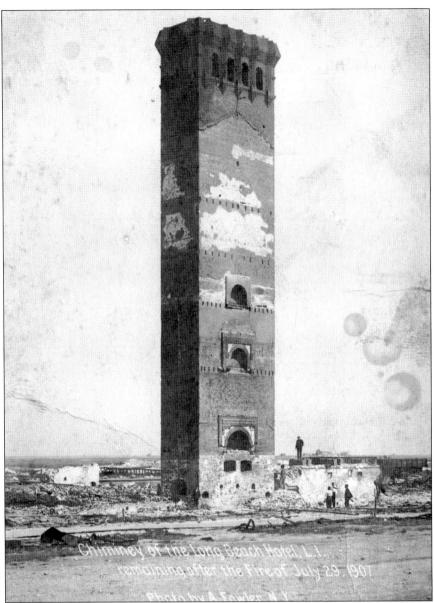

Chimney of the Long Beach Hotel, L.I. remaining after the Fire of July 29, 1907 Photo by A. Fowler, N.Y.

On July 30, 1907, the *New York Times* reported, "The Long Beach Hotel, for more than a quarter of a century among the largest hostelries on the Atlantic Coast, was burned to the ground at 5 o'clock yesterday morning." Senator Reynolds, who now owned the hotel, and his good friend, Senator McCarren, were both in residence at the time and their quick action contributed greatly to the evacuation of the 1,400 guests without a single life lost. The origin of the fire is unknown, but it did destroy one of the adjoining cottages, the hotel dormitory, the chapel, a newly erected power plant and two strings of Long Island railroad cars on a siding at the back of the hotel. A wind shift saved the other cottages that dotted the half-mile of boardwalk eastward from the hotel. The central chimney shaft was the only vestige of the grand hotel that remained standing. With financial assistance provided by Paul J. Rainey, Senator Reynolds and builder Ed Johnson utilized the chimney's bricks to build the Long Beach Casino's chimney in 1908. (Courtesy of Mark McCarthy.)

Two

Building a Place
to See and Be Seen

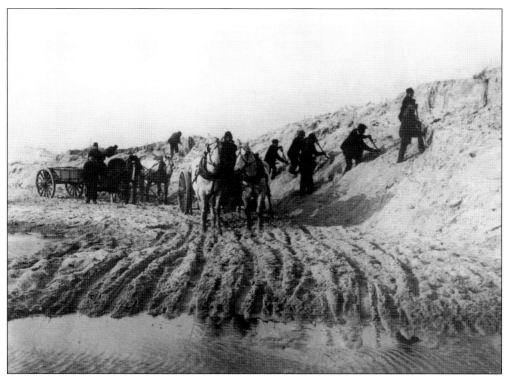

Undaunted by the fiery loss of the Long Beach Hotel, Senator Reynolds turned his focus to the blank canvas he had in his possession—the Long Beach sandbar. Upon it he would create a playground that would incorporate the architectural and scientific innovation he gleaned from the 1893 Columbia Exposition. Reynolds combined that knowledge with his experience creating Coney Island's Dreamland and began to level the barren dunes to create his planned community.

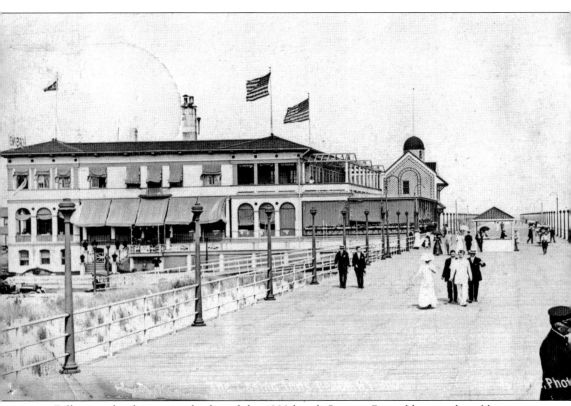

Following the destruction by fire of the 1880 hotel, Senator Reynolds moved swiftly to garner capital to bring into reality his vision of a seaside planned community on his now almost barren sandbar. He drew to his aid a company of financiers and real estate men and together they capitalized his dream. Included in the construction of the Casino, the first of his lavish buildings, were the bricks salvaged from the chimney of the 1880 hotel. The Italian Renaissance–styled Casino erected by builder Ed Johnson was not built for gambling but offered many of the 1880 hotel's plush amenities for dancing and socializing. Among these were private dining rooms on the second floor, along with a dozen bachelor apartments with baths. The terrace was covered with a glass roof, over which water constantly flowed so that the restaurant and café beneath would always be cool. An open bar and grill, a rathskeller, a complete ice manufacturing plant, and a $30,000 equipped kitchen were among the many other features designed to keep people and their money coming to Long Beach.

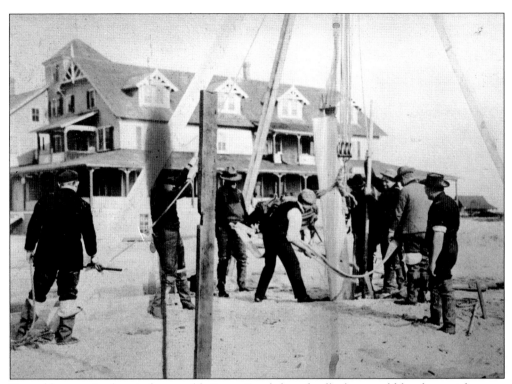

Reynolds conceived an indestructible Long Beach boardwalk that would be the social center of his planned community. It would be the place to see and be seen. The 50-foot-wide walk, supported by concrete piles, was 10 feet above the high water line along a stretch of beach with 75 feet between it and the ocean. A concrete plant for molding the piles was established near the beach. Instead of driving them in, the piles were jettied by pumping water through a pipe molded into the center of each, driving away the sand at the bottom, and gradually sinking the pile into place. This innovative engineering feat remains today as testament to the senator's embrace of the most modern technology, for it is the same 1907 concrete piles that support all who trod or bike upon the often replaced wooden boards of today. (Below, courtesy of LBPL.)

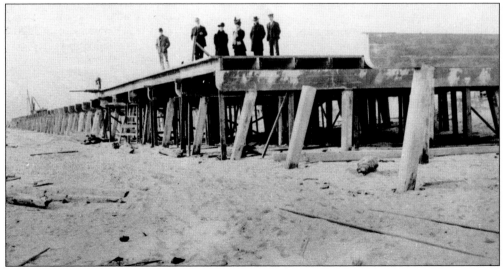

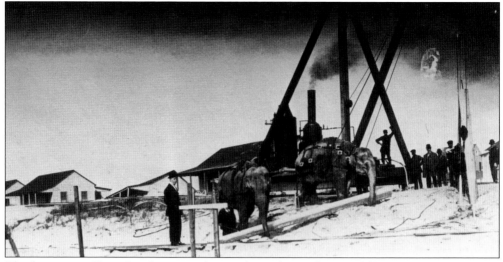

The dream city of Long Beach promised many things, but nothing could have equaled the sight of two elephants at work on the beach. Ever the showman in search of publicity for his Long Beach projects, Reynolds had two elephants brought from Dreamland and sent on foot in October 1907 to Long Beach. Crowds along what is today Sunrise Highway were treated to the sight of the two elephants, Roger and Alice, trudging along and kept in check by their tiny Hindu master, Folga Bey. They crossed the marshlands by barge and were put to work at the boardwalk site. Using their heads and trunks, they pushed and maneuvered one timber after another into place. With this wonderful demonstration, Reynolds achieved a publicity story that, even to this day, there are those who believe that the elephants built the boardwalk. (Courtesy of LBPL.)

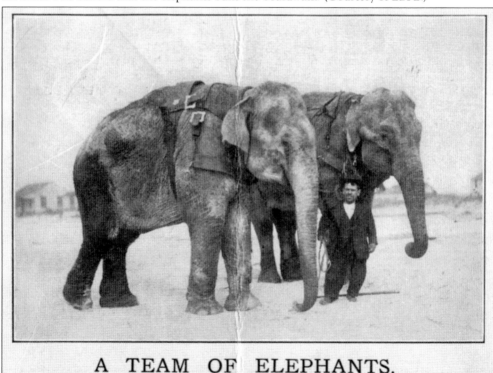

A TEAM OF ELEPHANTS.

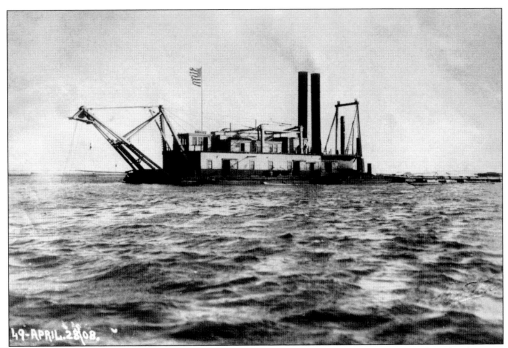

Simultaneously building the Casino and the boardwalk, Reynolds commenced a third major project, dredging the waters north of the Long Beach sandbar. He created a new, deeper and wider waterway to afford safe anchorage for all sorts of small craft and a place for aquatic sports. Three dredges, each with three teams totaling a workforce of 320 men, were put to work day and night pulling up 10,000 cubic yards of sand per day. The dredges would discharge a mixture, 90 percent water with 10 percent sand and shells, through giant pipes, which were moved from time to time to cover the island. The sandbar was thereby raised 9 feet above the mean high water mark and made into a rectangular island in keeping with landscape engineer Charles W. Leavitt's rectilinear grid design for the Estates of Long Beach. (Courtesy of LBPL.)

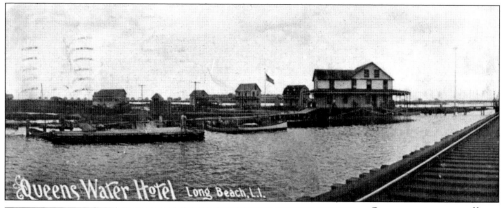

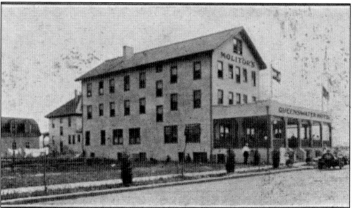

Queenswater
Hotel.
and FISHING STATION
LONG BEACH, L. I.

Near Ocean *On the Bay*

The best fishing in the vicinity of New York

B. MOLITOR, Long Beach, L. I.
Telephone — 26 Long Beach

Queenswater, a small island midway in Hempstead Bay, between Barnum Island and Long Beach, was noted on the Long Island Railroad's timetables as "one minute before Long Beach." In 1879, Bernard Molitar built a hotel and cottages on the island, which he leased from the Town of Hempstead. The Queenswater Hotel was a skeet shooter and fisherman's haven. As a result of the dredging process that filled in the marshes and transformed the sandbar, Queenswater Island, with its hotel, came to be annexed to the island of Long Beach and was renamed the Bayview Hotel. Rumrunners enjoyed easy boat access to the hotel during the Prohibition Era. Among the hotel's guests was the infamous Bugsy Siegel and notable silent screen actress Gilda Gray. The hotel remained in business in the North Park area of Long Beach well into the 1970s. (Above, courtesy of Herman Druckman.)

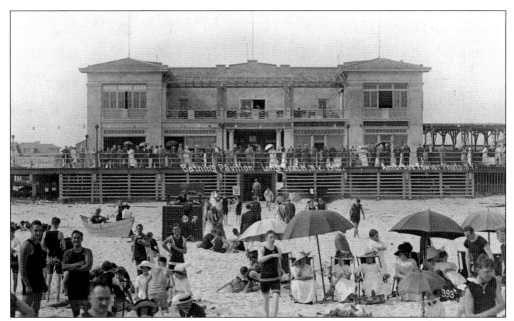

Another outcome the desire of Senator Reynolds to accommodate visitors to Long Beach was the National Bathing Pavilion. Housing 1,000 lockers, the pavilion afforded easy access to the beach from an entrance below the boardwalk. The foyer leading to that entrance was reminiscent of a Roman bath, complete with a marble footbath at its center. The pavilion opened on June 13, 1908, and was completely destroyed by fire on October 27, 1913. (Courtesy of Grant Geidel.)

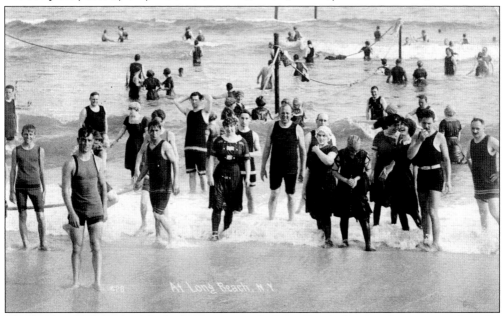

This Fowler photograph of the bathing scene on the Long Beach shore is what was seen from the balcony of the National Pavilion. Note the full bathing attire, particularly the black stockings. An established code of modest dress prohibited changing into beachwear outside of the pavilion. The code also dictated that women could not expose their legs; it was considered obscene to do so. Fines were levied for violations of the code.

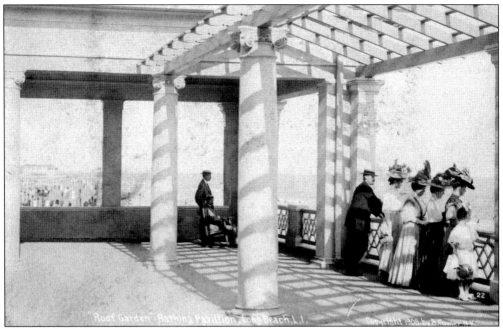

For the casual visitor or the prospective Estates of Long Beach investor, there was no better place to vicariously enjoy the beach and bathers as the expansive second floor terrace of the National Pavilion. This classically designed balcony with its pergola-like structure provided a scenic overlook and quiet respite for those who wished to just see or be seen, but not spend a day in the sun or surf.

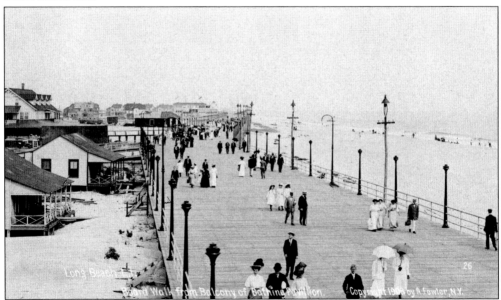

This boardwalk scene, looking east from the National Pavilion balcony, includes the construction site of the Nassau Hotel. The temporary bungalow-type buildings on the left were workers quarters. The dark building in the distance, to the left of the boardwalk, housed the sales office of the Estates of Long Beach. In 1913, that building was moved near Park and Chester Streets to serve as the village hall. (Courtesy of Herman Druckman.)

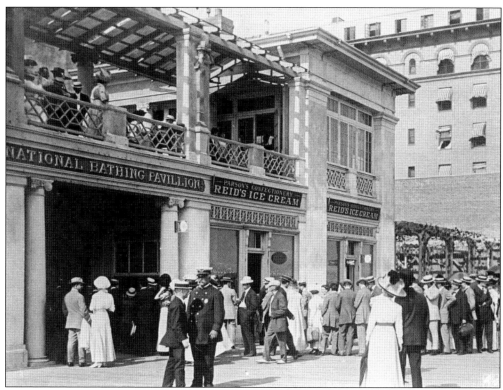

The National Bathing Pavilion, with its up-to-date accommodations, was the mecca for those who liked to indulge in surf bathing in safety and comfort. Its neoclassical columned, white facade gave an assuring sense of its pristine interior. In the summer of 1908, Nick Loritz, who presided over the pavilion, made a wager with real estate developer John DeSaulles that someday during the season the pavilion would be taxed to its utmost capacity. When he considered that the pavilion could accommodate 5,000 persons at one time, DeSaulles thought he won the wager. However, on August 18, 1908, Loritz's prediction came true. The image above attests to the popularity of the pavilion for day-trippers who arrived by car or train to enjoy the pleasures of the beach despite the wait in long lines in the hot sun while fully and formally clothed. (Above, courtesy of Doug Sheer.)

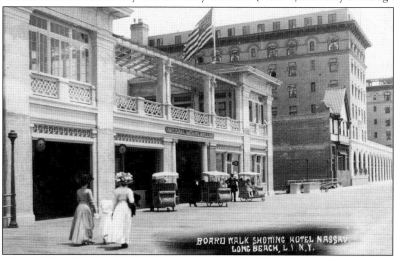

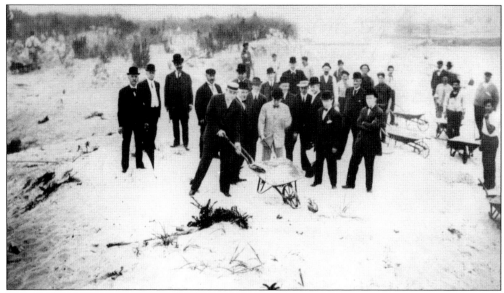

In June 1908, Senator Reynolds, along with a large contingent of investors, broke ground for the Nassau Hotel. Work commenced on December 1, 1908, and progressed through the dead of winter despite problems brought on by the wind and rainstorms of that Long Beach season. Transportation of material was a serious problem; boxcars that pulled into Long Beach each day to be unloaded would be covered by sand swept up in clouds by the winds. A modern structure of light-colored brick was erected on sand, fronting 800 feet on the boardwalk and 150 feet on National Boulevard. A no less remarkable feat is that this completely fireproof, million-dollar city hotel built on sand was put up in the space of six months. The Nassau Hotel opened in record time on June 19, 1909. (Above, courtesy of LBPL.)

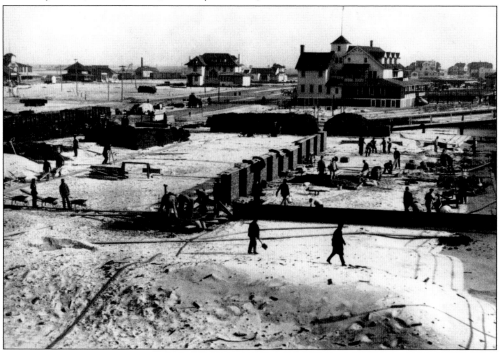

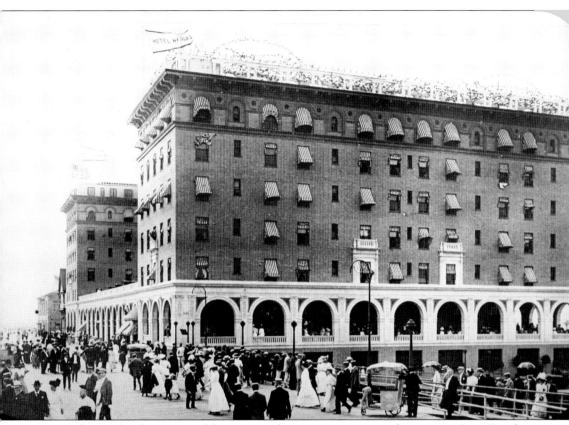

Uniquely designed and constructed for year-round occupancy, as opposed to previous Long Beach hostelries, the structure of the Nassau Hotel was a strong departure from their Edwardian opulence. Embodying all the conveniences and luxuries of the modern city hotel, its H-shaped plan afforded a view of the boardwalk and the ocean for most of the 320 rooms. A spacious and impressive interior design was created by the two-story height of the ceilings of the west wing's main dining hall and of the lobby in the east wing. A broad corridor gave access to the shops and bazaars on the boardwalk. Arched porticos and an open veranda were gateways to and from the hotel for boardwalk strollers. A most striking feature was the immense foyer fireplaces made of Caen stone imported from France. Atop the east wing, a roof garden's lights twinkled for those who came to see and be seen as much as to dine. For more than a century, this impervious building has stood at the boardwalk in many guises just as it does today as the Ocean Club Condominium.

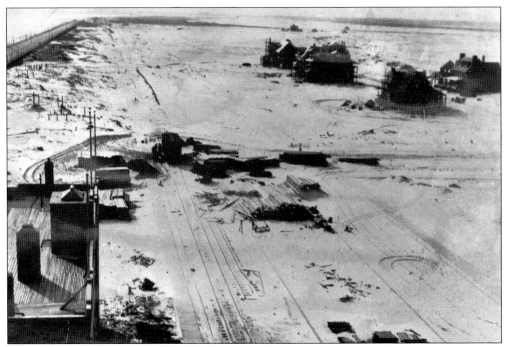

The focus of the planned community of Long Beach was its large stucco-sided international style "cottages," built to the specifications of covenants established by Senator Reynolds. Roofs were made with red clay tile and the streets that bordered the 5-lot-wide homesites were paved with red brick. The images here are of the cottages under construction along West Penn Street in 1909. The lack of foliage and the barren quality of the area north from the boardwalk is striking. One can readily understand that air-conditioning was not a necessity for houses having nothing to block the cool ocean breezes. Validation of the 1909 date of construction of the Historical Museum and its neighboring houses has been supplied by the image above. Another perspective of the scene appears in the photograph below that includes the Christopher Columbus Wilson house that stood on the corner of West Penn Street and Laurelton Boulevard.

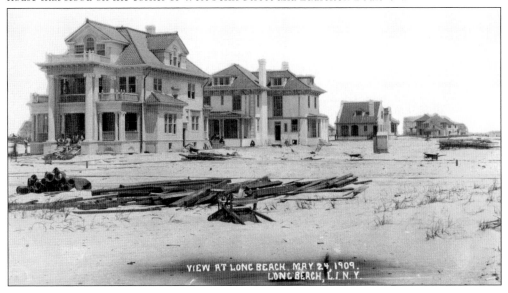

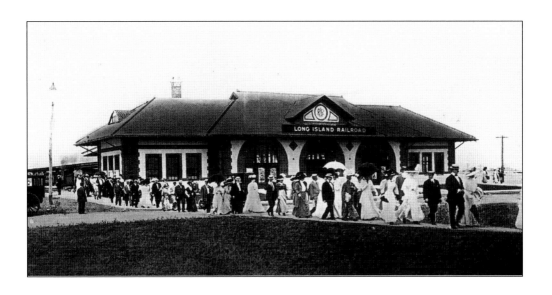

In an agreement with the Pennsylvania Railroad, Senator Reynolds committed to building a Long Beach dedicated to accessibility by road and railroad instead of what would seem more natural for this seaside location, namely the building of piers and anchorage for steamships and large watercraft. In turn, the railroad guaranteed him that in 1910, his community would be serviced by the electric track. Built to address the advanced passenger system of the railroad, the architecture of the modern 1909 Long Beach Railroad station was far removed from the romantic past of its predecessor. The building that remains today had its beginning with a nod to the Craftsman-style architecture of the period. The green-tiled roof has been replaced by one of red tiles, but the century-old brick facades and original encaustic tiles remain.

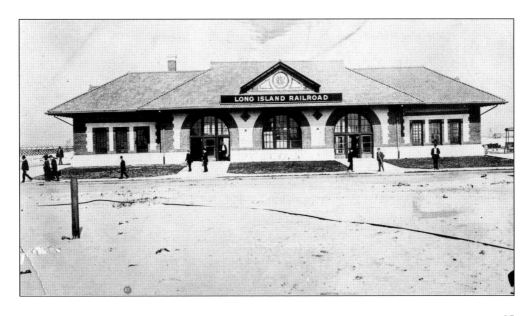

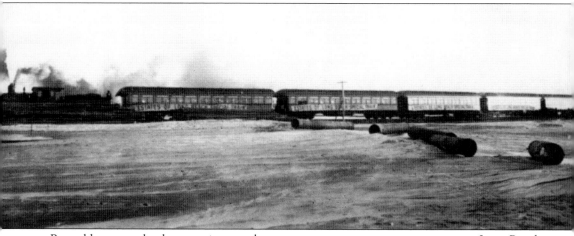

Reynolds arranged to have a private parlor car to transport prospective investors to Long Beach. In keeping with his flair for publicity, he had "The Estates of Long Beach" emblazoned on the side of the car, which was placed as the first car so that his guests would alight closest to the station building. Much like today's resort time-share sales pitches, prospects were treated to a day of sun and sea in return for making the trip from New York City to be wooed into investing in the estates property. However, not everyone was as gullible as he would have them. Upon alighting from the train, many were aghast at the sight of an almost barren, treeless sandy tract. Lacking the capacity to visualize what was not yet real, they declined further inducements and returned to New York with their money intact. One of Reynolds's favorite lines was, "All the world will be coming to Long Beach when the bands play, but the man of vision will buy there today." (Courtesy of LBPL.)

Three

A SEASIDE
PLACE OF PLAY

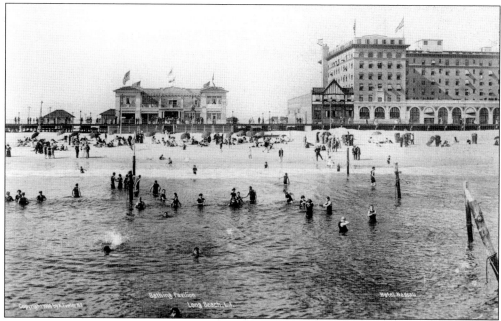

At the century's turn, the concept of guiltless play was taking hold. It inspired Senator Reynolds to create Coney Island Dreamland, which emulated the Columbian Exposition of 1893. Evident in its architecture and focus on scientific innovation was the vision Reynolds would bring to Long Beach. By 1910, his Long Beach stage was erected and now he rapidly approached his finest hour when the sum total of his drive would produce a "City of Play."

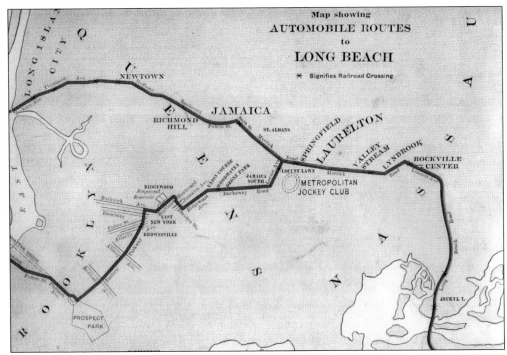

The auto excursion to Long Beach from Brooklyn or New York City presented quite a challenge. From the city, one could begin by crossing either the Brooklyn or the Manhattan Bridge and then through Brooklyn. Another option presented in 1909 was the Queensboro Bridge and in 1910 the Midtown Tunnel. All routes joined at Jamaica and continued to Nassau's primary "highway," Merrick Road. In Rockville Centre, the Long Beach-bound traveler veered south to the primitive Long Beach Road and on to the seaside. The excursion from the boroughs took hours, and there was no welcoming hospitality along the route—just hot, dusty winding roads. On June 29, 1927, the Far Rockaway Bridge opened a new pathway to Long Beach, and in the 1930s, the WPA's Loop Parkway toll bridge provided another path as did the million-dollar bridge in 1922.

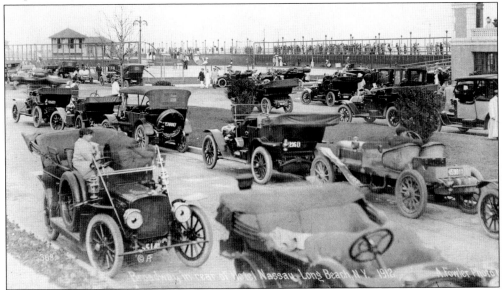

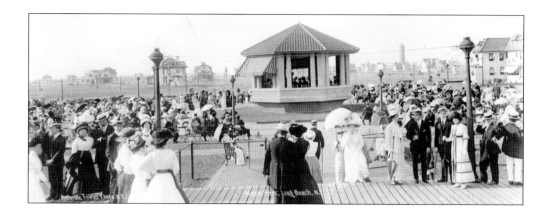

An early entertainment center, the Music Park was created by Senator Reynolds to replace the fire-destroyed music pavilion of the 1880 hotel. An open walled hexagonal bandstand was erected in the center of the park that ran alongside the boardwalk to the east of the Nassau Hotel. The red, clay-tiled roof of the rotunda was supported by both square pillars and round columns, creating an interesting architectural structure. Benches and chairs lined the grass-covered sands for the comfort of the audience who, much like today, traveled by car and train for the free concerts at the beach. Musicians were shielded from Long Beach's strong afternoon sun by awnings rolled down on the rotunda's western sides. Nathan Franko presented programs of popular music. John Philip Sousa's famed New Marine Band, with its march music, always drew a large appreciative audience.

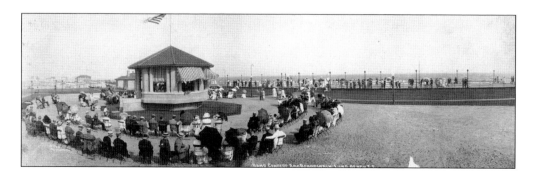

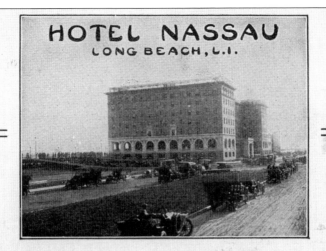

HOTEL NASSAU

A distinctive Hotel of the highest class with every modern comfort and convenience.

Open throughout the entire year, with particular attention given to the care of Winter residents.

Rooms with and without private baths. All bathrooms have hot and cold salt and fresh water.

Twenty-four miles from New York City (35 minutes) via Long Island Electrified Service from Pennsylvania Terminal and Flatbush Avenue Station, Brooklyn.

Conducted on European and American Plans, alternately, with rates as moderate as is consistent with the highest order of fare and service.

EXCELLENT MUSIC—DANCING
SURF BATHING—TENNIS—ROLLING CHAIRS
FIVE MILES *of splendid* BOARD WALK

A delightful Motor Trip over excellent roads through the most attractive section of Long Island. On the Merrick Road. Garage.

THE BATHING BEACH AT LONG BEACH IS CONCEDED TO BE ONE OF THE FINEST ON THE ATLANTIC COAST

BARNETT & BARSE CORPORATION, PROPRIETORS

Already well versed in the art of publicity and as one with the skill to sell to anyone whatever he built, Reynolds employed every form of public relations media to insure the success of his new Long Beach ventures. Printed on glossy paper was his regularly issued *Long Beach Review of the Progress at Long Beach*. Files in the archives of New York newspapers contain an incredible number of obvious press release articles touting his Long Beach resort. Publicity brochures and flyers promoted in great detail what one could find in the beauty of leisure time spent at the sea in Long Beach. Advertisements such as this, promoting the Nassau as a high-class hotel appeared far and wide in newspapers, magazines, and journals to draw attention and interest to the luxurious playtime that could be had at his beach, boardwalk, and hotel.

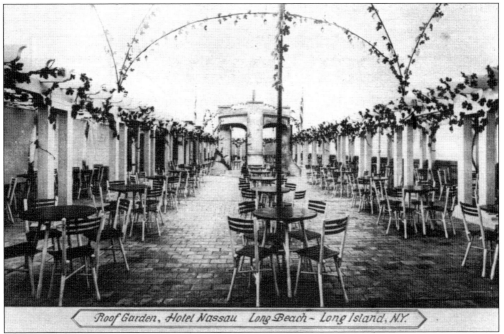

Roof Garden, Hotel Nassau Long Beach – Long Island, N.Y.

High above all, providing a vista encompassing the beach, the ocean horizon, and New York City, was the Nassau's most predominant feature, the Lunetta, its rooftop garden where guests could take afternoon tea or dine and dance under its twinkling lights. Also atop the roof was the most important wireless station along the south shore. It made possible communications to passing vessels with messages reaching from 500 to 1,000 miles. (Courtesy of Herman Druckman.)

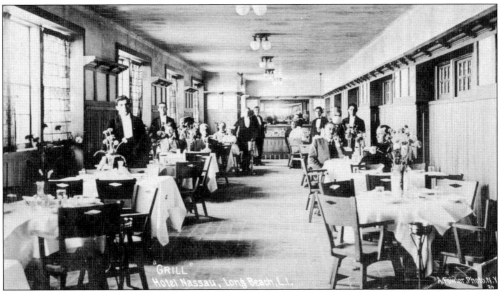

In building the Nassau Hotel, Senator Reynolds took great pride in creating a setting that would attract what are called the A-List people. A relaxed dining experience could be had in the Grill Room where one's steak would be emblazoned with a searing hot iron bearing the words Nassau Hotel. The room was finished in paneled quartered oak; against the walls were small, round tables below leaded paned windows.

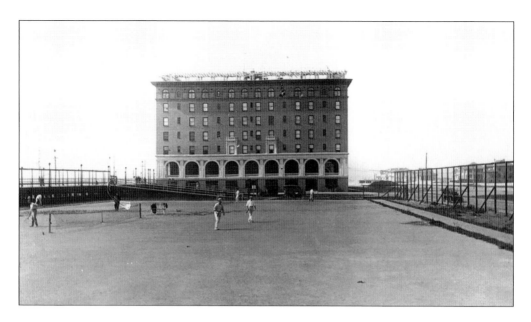

In addition to the lush accommodations of the Nassau Hotel, sport-loving men and women were enticed to spend time at Long Beach by the availability of expansive tennis courts. Located across National Boulevard to the east of the Nassau Hotel, this added attraction was the site of many challenging tennis tournaments. In June 1908, personal invitations to attend the first tennis tournament were sent to a select group by Long Beach Tennis Club president, Senator Reynolds. He had beautiful loving-cup trophies especially created for the tournament. Some of the most expert players were dismayed by having their well-aimed balls sent astray whenever the ocean breezes gusted shoreward. That experience ensured that a part of a Long Beach tennis education would be the ability to judge the wind as well as the distance.

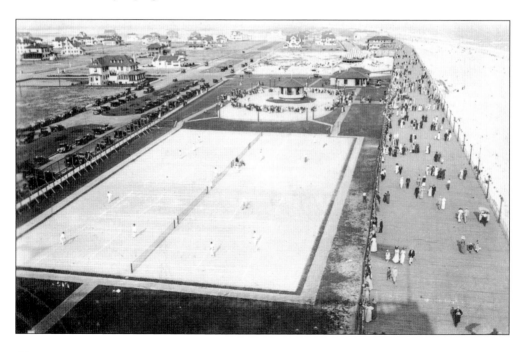

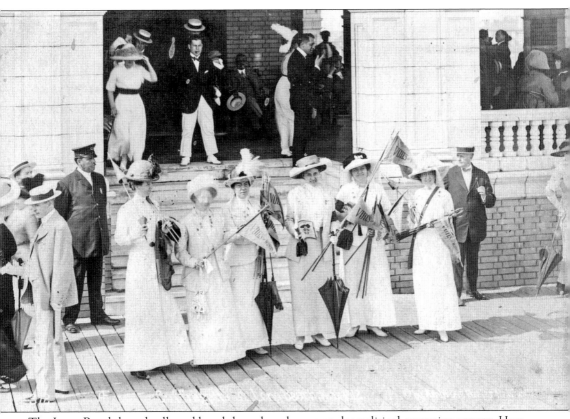

The Long Beach boardwalk and beach have long been popular political campaign venues. Here at the boardwalk entrance to the Nassau Hotel are the suffragettes who strolled the boardwalk equipped with "Votes for Women" banners, parasols, and yellow bags for their suffrage papers. The *New York Times* reported that Mrs. Wilmer Kearns presented her "voiceless speech" from the ocean itself. What she did was to have a speech written on large cards displayed on a yellow tripod, with its legs in the sand on the edge of the surf. The *Times* article went on to say that the audience was quite attentive and called out "down in front" when bathers coming out of the water blocked a view of the cards.

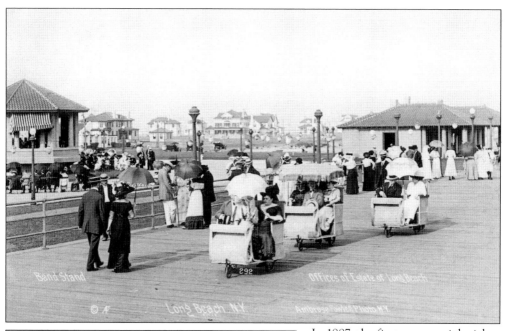

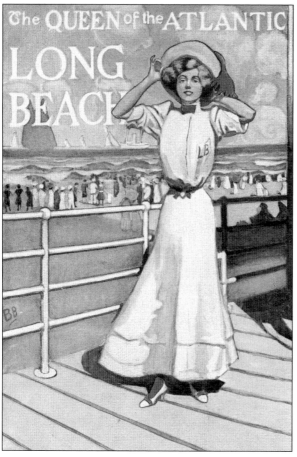

In 1887, the first commercial wicker chairs were pushed along the Atlantic City boardwalk with such success that, as boardwalks were built, rolling chairs soon were seen on them. As seen in this image, Long Beach was no exception. The chairs were handmade rickshaw-like baskets on wheels pushed by African American men. It is said that one would experience a dream-like tranquility by a boardwalk ride in a rolling chair. (Courtesy of Herman Druckman.)

This image is of the cover of a 1908 Reynolds-created publication distributed from the Manhattan office of the Estates of Long Beach. It exemplifies Reynolds's use of only the ultimate forms of artistic advertising to attract wealthy investors to the "Queen of the Atlantic" Long Beach playground. Promises of the summer home of the future are couched between poetic phrases and romantic pictures throughout the 24-page booklet. (Courtesy of Kevin O. Brennan.)

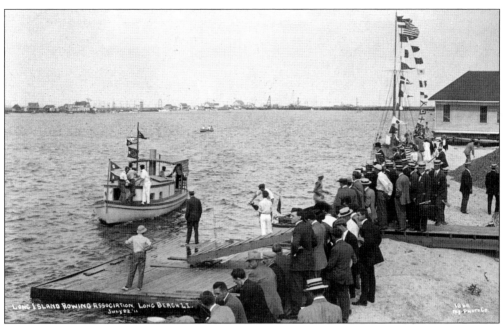

Much to the consternation of the baymen whose oyster industry was threatened, the dredging of Hempstead Bay created Reynolds Channel, a boatman's and water sports enthusiast's paradise. The Long Beach Rowing Association built their clubhouse on the bay side of the island from which they conducted their races. The image below is of the Sportsmen's Fishing Club, built on a marsh in the middle of the channel. It was said that anglers never had such opportunities to catch fish and that they certainly took advantage of the schools of summer mackerel. The $500,000 Reynolds Channel also connected Long Beach by boat to the fashionable summer colonies at Woodmere, Lawrence, Cedarhurst, and Hewlett. This new navigable channel was about 4,000 feet long, 20 feet deep, and 200 feet wide. The channel also had commercial value by creating an alternative freight transportation route.

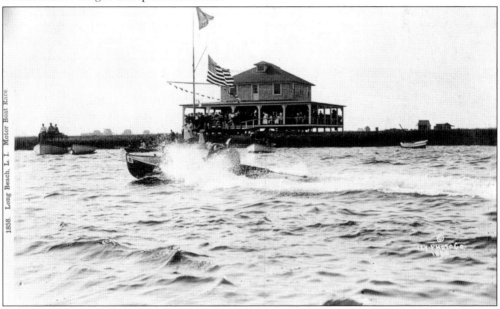

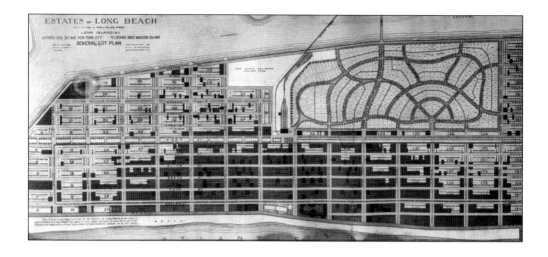

Reynolds envisioned an exclusive area with winding roads and larger homes, but when August Belmont's funding to create bayside Sandringham failed to materialize, he turned back toward the ocean to build his international resort. The Chateau des Tourelles, built in the fashion of a Bavarian castle, signaled his move to imitate the watering spots of Europe. Across from the railroad station, it was convenient for New York City's theater crowd who came to the new playground to dine, dance, and make the New York papers with their midnight frolics. Reynolds sold the hotel to brewer Joseph Huber who named it the Hotel Huber. It was sold in 1914 and renamed the Long Beach Inn. Sold once more, it became the Lafayette Hotel. On March 30, 1930, a huge fire destroyed the building. Rebuilt in a more modern style as the New Lafayette Hotel, vestiges of it remain at the corner of Edwards Boulevard and Park Street.

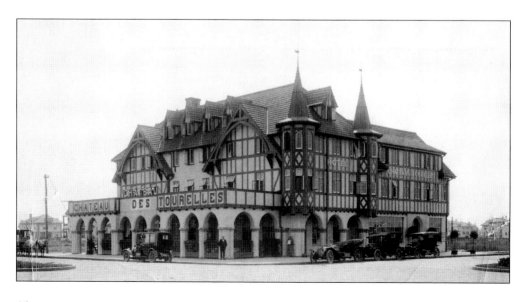

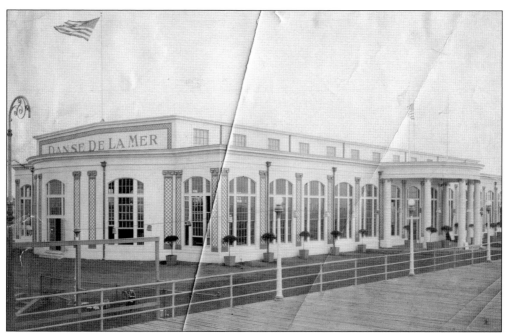

English-influenced latticework, the common decorative architectural detail found in these two images, is a significant indication of the international theme that Reynolds would carry out in all the pieces of his city of play. The construction on the boardwalk of Danse De La Mer as a place for public pleasure, although inspired by the success of Dreamland's dance pavilion, was English decorated and French named. Purchasers of Estates of Long Beach house sites had available to them a variety of international styled "cottages" that would meet the standards established by Reynolds for his planned community. The English-style cottage in the image below was built in 1910 for the Henry Cohen family and still stands on its 5-lot-wide site on West Beech Street.

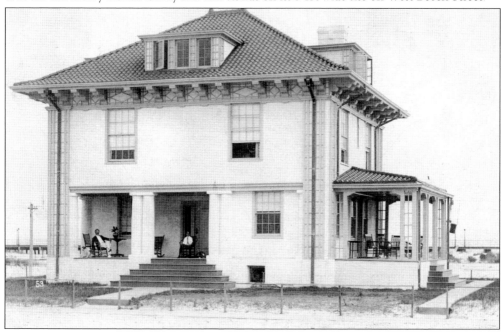

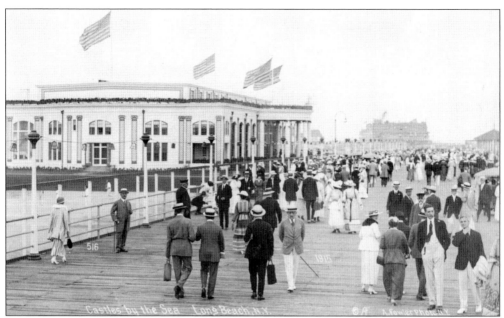

To attract more players to his boardwalk, Reynolds wooed to Long Beach the most sensational dance performers of the time, Vernon and Irene Castle. With the Danse De La Mer, he had the perfect dance pavilion to accommodate the dancing couple. The name of the pavilion was changed to Castles by the Sea, and its opening was featured in the 1915 silent film *Whirl of Life* in which the Castles made their motion picture debut. That movie includes a scene shot from the water toward Castles by the Sea and is the first action photography of the beach and boardwalk. When performing at Castles by the Sea, Vernon and Irene Castle would take up residence in the picturesque Estates of Long Beach, hollow-tile constructed, white stucco Joseph Stehlin House on Broadway near Jackson (now Edwards) Boulevard. (Below, courtesy of Doug Sheer.)

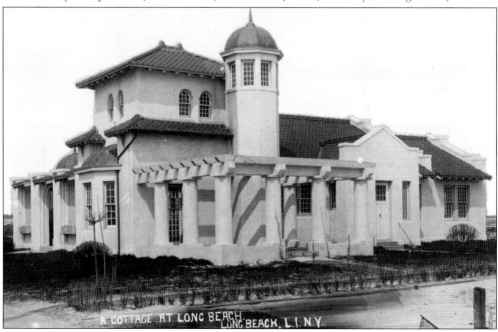

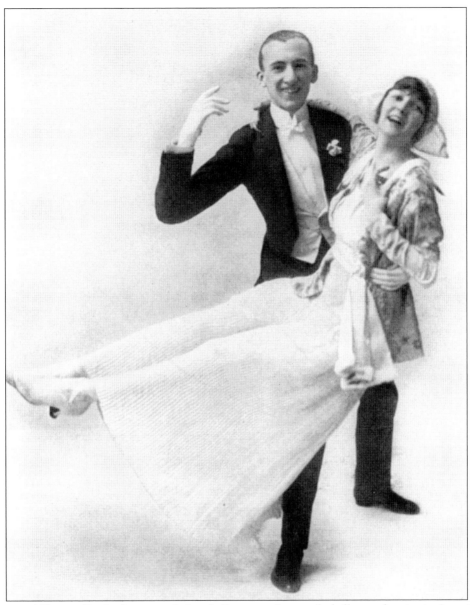

Irene and Vernon Castle almost single-handedly initiated a rage for ballroom dancing in America. Although they did not invent social dancing, they were the first to make a career of it. They started what was called the "dancing craze" by introducing or popularizing such dances as the tango, and their "animal dances"—the fox trot, chicken scratch, kangaroo hop, etc. Prior to 1913, the Castles had to create their adaptations of ragtime steps without musical accompaniment because few orchestras could provide the required syncopated rhythmic accompaniment they required. While dancing at a private party, they were enthralled by the rhythms of James Reese Europe's Society Orchestra, and they hired him on the spot as their personal musician. By that time, Europe's name and that of his orchestra were established as the most famous of the African American bands. The collaboration of the Castles with James Reese Europe produced their signature piece, *Castle Walk*, plus numerous others such as *Castles Lame Duck Waltz* and *Castle House Rag* and brought the crowds dancing into Castles by the Sea on the Long Beach boardwalk.

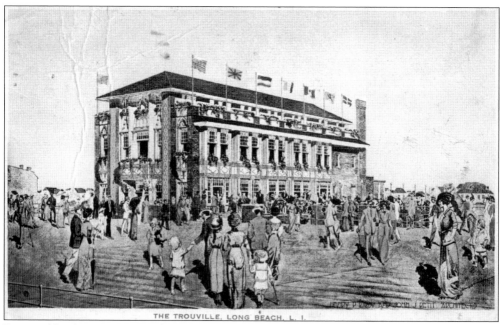

THE TROUVILLE, LONG BEACH, L. I.

Designed by the prominent architectural firm of Kirby and Petit, the Hotel Trouville was erected on the boardwalk in the 20th century's teen years. The assortment of the flags of many countries aligned across the hotel's rooftop attested to Reynolds goal of enriching the lives of his Long Beach visitors by bringing a European style of leisure to his boardwalk. The elegance of its facade promised an interior of international opulence and as can be seen in the image below of the Turkish dining room, it more than met that promise. Here was the ultimate in plush dining in a setting to rival the best that the French Riviera had to offer. Unquestionably, this was Reynolds magnificent move to replicate the edifices of the French watering places of which he had become enamored during a trip abroad in 1911. (Courtesy of Herman Druckman.)

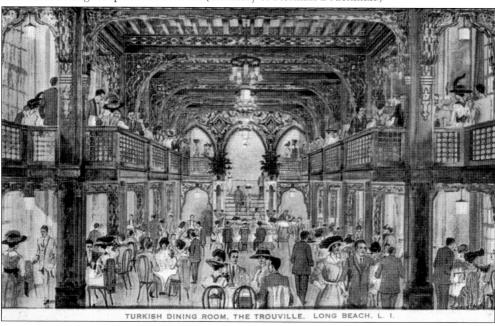

TURKISH DINING ROOM, THE TROUVILLE, LONG BEACH, L. I.

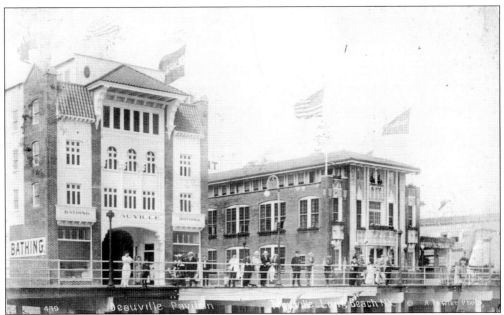

The Hotel Trouville and its companion, the Deauville Bathing Pavilion, could be viewed as a balance on the east to the Nassau Hotel and the National Bathing Pavilion on the west. To the right of the French pair was the Casino, Reynolds earliest restaurant construction on the boardwalk. In all, they were his continuing effort to draw people and money to Long Beach with opulence and innovation. Although to a degree he was replicating the original concepts of the 19th-century Long Beach Hotel, his efforts were designed to keep his wealthy patrons entertained and amused as illustrated by the party scene at the Trouville in the photograph below. Like the National, the Deauville Bathing Pavilion offered both seasonal and daily entrance fees to the burgeoning crowds that flocked to the seaside at Long Beach. (Below, courtesy of Doug Sheer.)

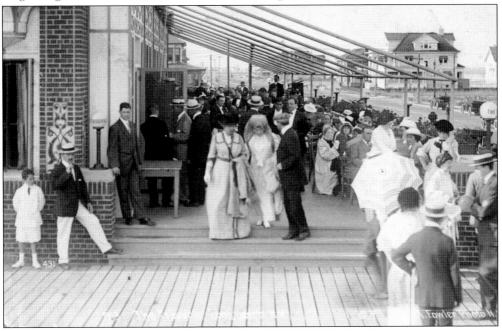

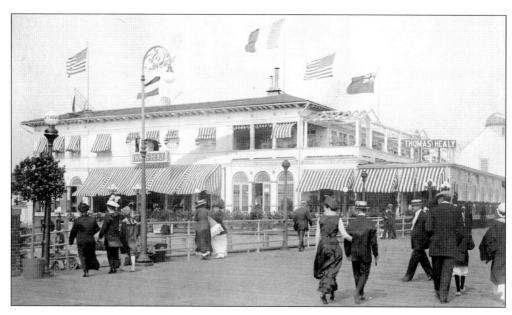

The bon vivants of New York City and Long Island frequented the new boardwalk Casino for an evening's entertainment especially when Rudolph Valentino was in residence teaching the tango on its large dance floor. On May 12, 1915, in another move to amass funds to continue the building of his city of play, Reynolds and his cohorts sold the Casino to New York City restaurateur Thomas J. Healy, who at that time had the Casino under lease. Healy equipped the old Casino with an eye toward making it one of the foremost pleasure venues in Long Beach. For those who could not come by motorcar, Healy arranged to run the "Thomas Healy" train from Pennsylvania Station at 5:00 p.m. and 6:24 p.m. The return trip was scheduled to depart Long Beach at 1:20 a.m.

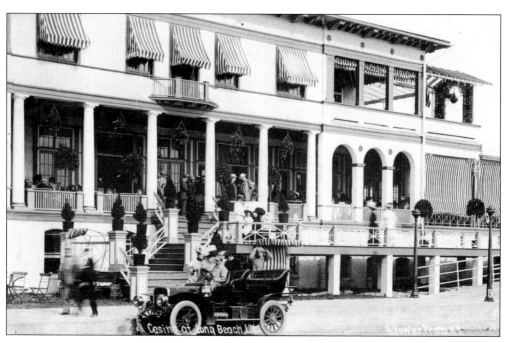

Publicity for Long Beach touted this seaside enclave as Queen of the Atlantic, Neptuna by the Sea, and in this advertisement for the Casino as The Armenonville by the Sea. This representation is in keeping with Reynolds's international plan to link Long Beach with the aura of the French Riviera. Evident, too, is the appeal to auto owners of the accolade to Merrick Road and of the proximity to New York City.

In an attempt to prove that a direct route to Long Beach from Manhattan is a mere 23 miles, this rather bold rendering borders on the edge of artistic license for it indicates the route of the crow. The map is another piece of exaggerated publicity designed to tempt the vacationer and the city dweller that in no time at all they could be reveling at the seaside in sun and salt air.

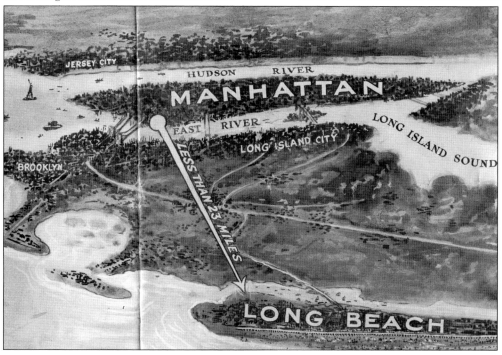

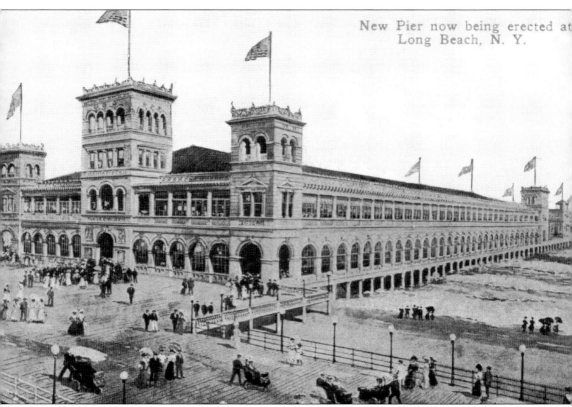

New Pier now being erected at Long Beach, N. Y.

The Atlantic City Steel Pier was viewed as a worthy project to be surpassed in Long Beach. The new pier was to be built on concrete caissons, of steel construction throughout. The concept of a pier stretching 1,500 feet out into the ocean and that could accommodate 25,000 persons was readily bought into and greatly publicized. Indeed, the promise of the $1.5 million Rainey's Pier to be built east of the Casino at Roosevelt Boulevard, the planned end of the boardwalk, prompted Healy's purchase of the Casino. John Russell Pope's design called for a 5,000-seat convention hall, a recreation park with promenade, a yacht, and a steamboat landing. Facing the pier on the boardwalk would be an octagonal shaped open-air theater. Published renderings of the pier, such as the image seen here, were advertised in brochures and on postcards such as this. However, John DeSaulles, president of the Pier Company, failed to bring the dream to reality in Long Beach. Nor did the pier planned for Coney Island, which research has revealed is the actual subject of this misinforming postcard.

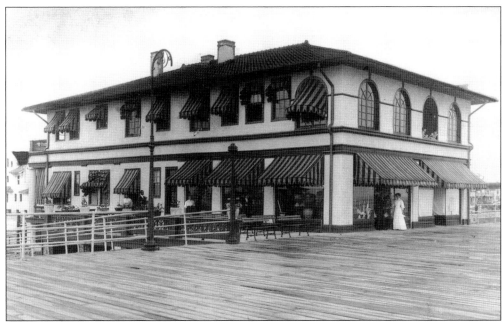

If Atlantic City had it, then Long Beach would have it better! The boardwalk was the commercial center of Reynolds's planned community, and it was there that he agreed to allow Charles W. Fuller erect a department store. Fuller was a successful entrepreneur with stores on the boardwalk at Atlantic City and at St. Augustine. The plans he submitted to Reynolds indicated his undeniable intention to surpass both of those in scope and attractiveness. Fuller's experience informed him of the wisdom of this new venture, in that he had gained the understanding that boardwalk strollers needed to look at more than sea and sand. Therefore, his three-story building was erected with large show windows along the boardwalk. In addition, he, like Reynolds, saw property as profit and extended the building to include rental apartments on its street side, seen below.

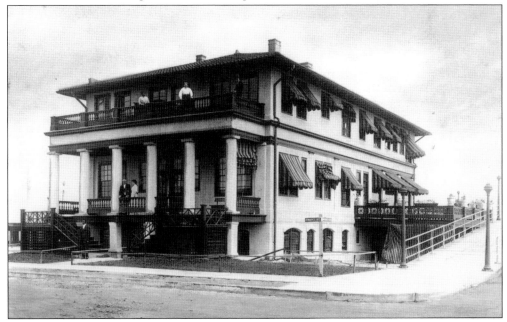

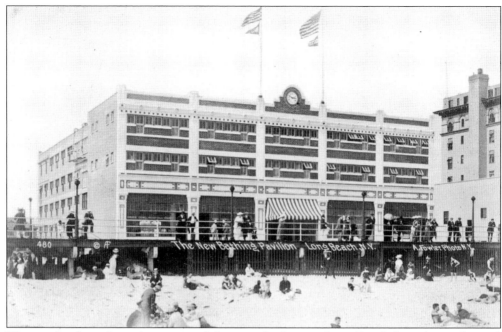

Thousands of people in their automobiles were flocking to Long Beach for a dip in the surf, creating a need for new bathhouses following the destruction of the National Bathing Pavilion. A five-level building of the same name, in a modern functional design, was erected on the burned plots of the former pavilion and adjacent beer garden. The location was a convenient one, as it abutted a new garage located behind the Nassau that was available to day-trippers as well as hotel guests. As the crowds grew, so did concern for their safety and so each bathhouse employed its own squad of "life savers." These young men were hired to not only look out for the safety of the bathers but also to set them up on the beach with chairs and umbrellas. (Above, courtesy of Kevin O. Brennan; below, courtesy of Herman Druckman.)

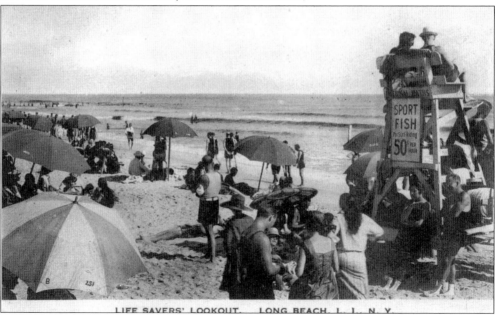

LIFE SAVERS' LOOKOUT. LONG BEACH, L. I., N. Y.

Typical of the high quality, artistically designed sales promotion brochures produced by Senator Reynolds to appeal to the "cultivated taste of New York City residents" are these images of the front and back covers of a 42-page booklet. Included in its pages were advertisements for fine New York City establishments such as B. Altman, Bergdorf Goodman, Steinway Pianos, Rolls Royce, as well as Westbury's Hicks Nurseries. Essays about Long Beach and what it had to offer contained statements such as "the whole sea city is a spot of color, of freshness, of beauty and the picturesque"—just as depicted by the sea green and golden colors of the artist's cover. Various Fowler photographs of Long Beach scenes were also used as illustrations.

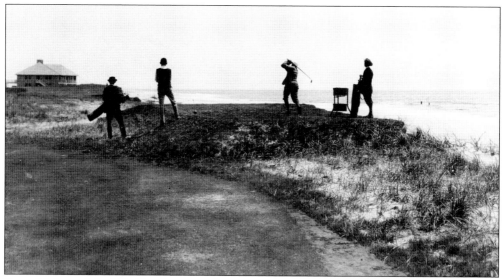

Reynolds formed the Lido Development Company and dredged 115 acres of the marshland on the bay side of the island to build a links golf course. Charles Blair MacDonald and Seth Raynor were brought in to design and construct the links course with assurances that there would be money aplenty and the freedom to build anything they wished. The turf building and same assurances were given to noted British groundskeeper, Peter Lees. Construction of the links course began in 1914 and took three years to complete. In 1916, Reynolds enlisted master builder Edward Johnson to construct the clubhouse. Four of the holes: seven, eight, nine, and 18 were located on the ocean side as were the tee offs for holes one and 10. Holes number one, six, seven, and 18 required hitting over sandy Lido Road. The entire course was windswept and challenging. (Below, courtesy of Mark McCarthy.)

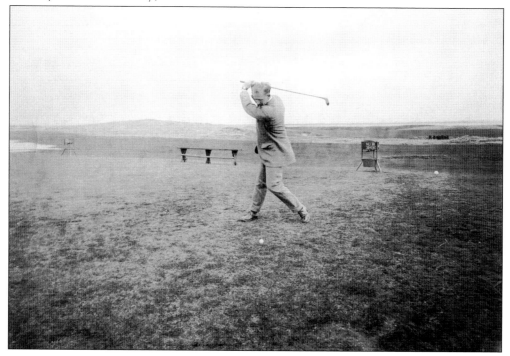

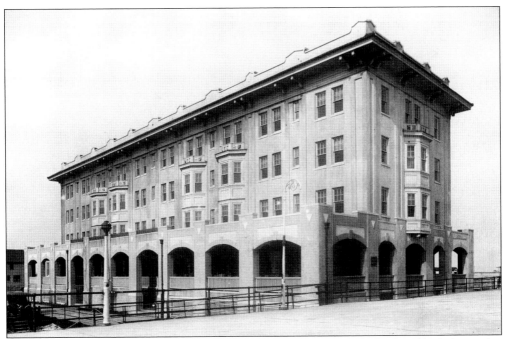

The eastern portion of Long Beach is seen in this view from the roof of the last hotel built during this glowing period, the Hotel Brighton. Advertised as "one of the most modern hotels on oceanfront," the Brighton was designed by Shubert Theater architect Herbert J. Krapp as an apartment hotel with a focus on families. Its private motorbus was dispatched daily to meet all trains. Guests could enter both the beach and the boardwalk directly from the premises. Its proprietor was Bertha Klug who had experience managing a family-type hotel along with her husband, Fred, who owned the Hotel Wellington, which still stands on Seventh Avenue and Fifty-fifth Street in New York City. Unlike the Wellington, the Brighton fell into hard times through several ownerships and in 2008 was razed and replaced by the Aqua, a luxury condominium.

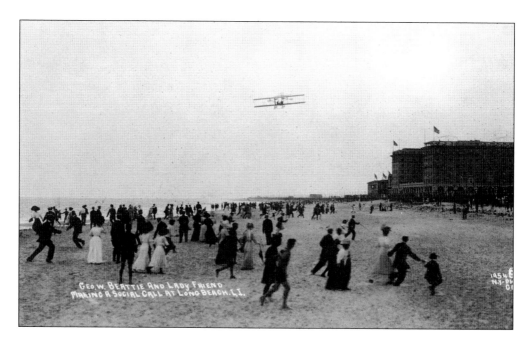

What better way to see and be seen arriving at the 1911 "in" place to play than by a Wright Aeroplane, piloted by "Geo. W. Beattie" [*sic*]. George William Beatty learned to fly at the Wright Flying School on Long Island. He earned his license, No. 43, after setting endurance records, including a solo landing in Manhattan's Central Park. He opened his own flying school in Mineola and flew celebrities to local destinations such as the Long Beach seashore where the crowds would scatter in fright upon his approach. He is seen here at Long Beach in 1911 with Genevieve O'Hagan, whom he later married. The National Air and Space Museum holds an extensive collection of photographs and documents related to his career as one of the "Early Birds," a distinguished group of fliers who soloed prior to December 17, 1916.

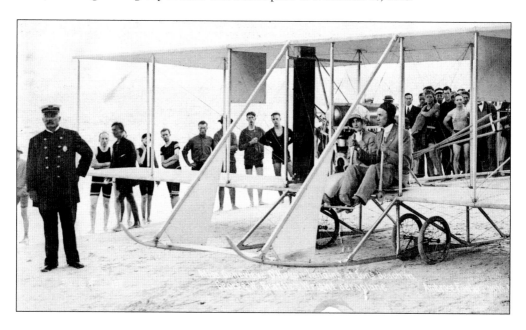

Four

From a Playground
to a Village

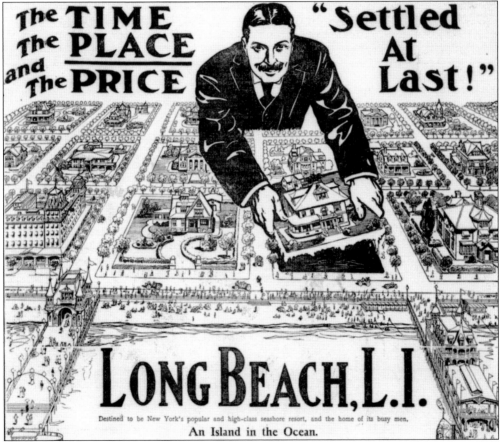

In a few short years, the development of Reynolds's planned community moved beyond the glitter of hotel and entertainment centers to efforts that would establish a vibrant and thriving village. Building covenants and enticing advertisements were designed to lure discerning investors to build substantial homes and establish businesses along restricted brick-paved streets and boulevards. The 20th century's teen years brought recognition of Long Beach as a healthful environment for family living.

Two real estate syndicates formed by Reynolds were the Elmohar Corporation and the Estates of Long Beach. The investors in those companies made it possible to acquire the dunes to level, fill in the marshes, join the pieces, and create the lots to be sold. Among those investors were wealthy financiers such as those seen here on the Long Beach boardwalk with Theodore Roosevelt. From left to right are Nassau National Bank of Brooklyn president Thomas T. Barr, Jacob Klipstein, Senator Reynolds, Roosevelt, and Long Beach Hotel manager Cal Dick. A choice of investment was available to those who had their eyes focused on the happenings at Long Beach; one could either buy building lots or buy stock in the Estates of Long Beach Company. Certificates of stock as proof of investment were issued until the company went bankrupt in 1918. (Above, courtesy of LBPL.)

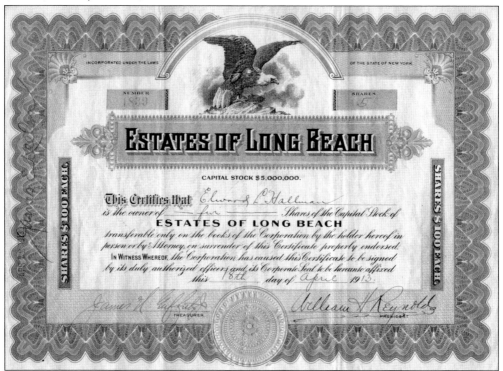

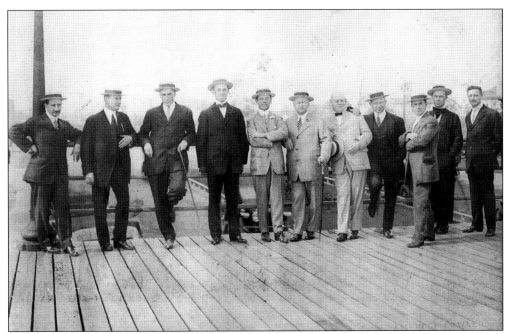

The well-organized sales force of the Estates of Long Beach Company worked out of an office on Fifth Avenue in New York City as well as from a small building at the boardwalk. Backed by the distribution of creative advertisements, such as the one seen here, they succeeded in selling, in just over two years, a trifle less than $675 million worth of building lots. The buyers of Long Beach lots were mostly wealthy seekers of a healthful, resort atmosphere in which to spend summers away from the heat of the city. The heart of the sales pitch of these handsome, young salesmen was Reynolds's progressive and innovative design elements that were available to prospective homebuilders. These included gas power, electric lights, and telephone lines and the most innovative inducement of all, salt and fresh water pipes to each cottage.

Own a Home at Long Beach

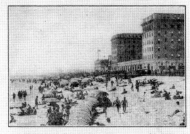

Seashore homes and cottages $2,500 and upwards

The Atlantic Ocean is at your front door with big stretches of the finest beach in all the world. Bathing is superb—and *safe*. The children can frolic on the sands to their heart's content and enjoy the delights of Ocean and Still Water bathing without danger. Excellent boating and fishing. Easy commutation to New York and Brooklyn. Excellent train service.

Regular bus service meets all trains.

Five minutes from station.

For all Information
Call at STUCCO OFFICE
Opposite Long Beach Railroad Station

EDWARD J. FARRELL
Sales Manager

Telephone 308 Long Beach

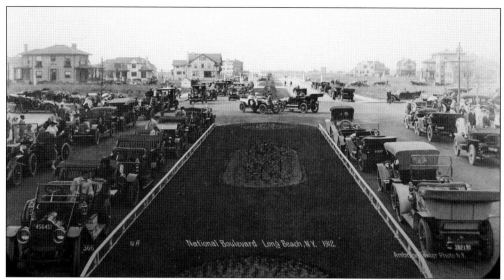

Reynolds believed, "Build it and the people will come." And come they did—traveling by car and by train and lured by his Estates of Long Beach advertising campaigns. Thus began Long Beach's eternal crowded-near-the-beach parking situation as evidenced by this 1912 photograph looking north from the boardwalk along National Boulevard. Wide, grassy malls planted with salt air tolerant floral beds were designed by Charles W. Leavitt Jr. to appeal to the aesthetic sensibilities of prospective property buyers who in the beginning years recoiled at the sight of the barren sandbar but were now arriving in huge numbers. As the Estates of Long Beach grew toward becoming an established planned community of streets and boulevards laid out across a rectilinear grid, people were attracted by its promise of healthful and entertaining seaside living. (Below, courtesy of Mark McCarthy.)

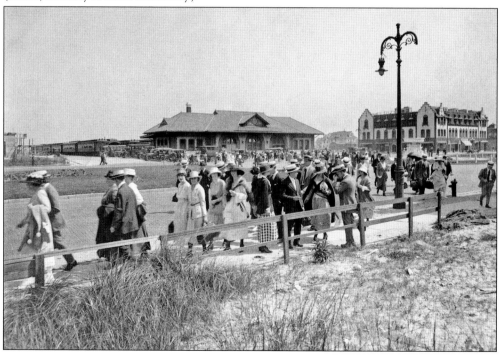

Covenants were placed on the building of cottages in the planned community. Red tile roofed houses set back 20 feet from the street were required. Minimum costs for house construction were based upon the size of the plot. A purchase of five lots required a cottage cost of no less than $7,000 in 1909. By 1913, more than 200 stucco-faced mansions, painted white or cream, rose north of the boardwalk. Construction of international style villas created residences that gave character to the growing community; many of them still survive, particularly around Penn, Beech, Olive, and Walnut Streets for a few blocks east and west of Edwards Boulevard. These two are on West Penn Street. The open turret-shaped sleep porches are now closed in to serve as rooms in the house below, while the Japanese-influenced, Craftsman-style cottage above houses the Long Beach Historical Museum.

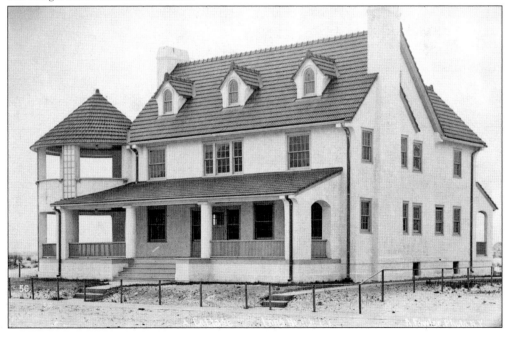

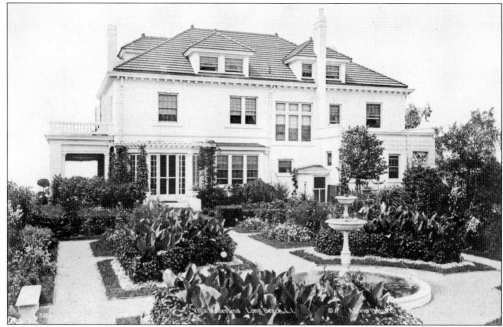

Among early estates property owners were several prominent physicians. Within the same block of each other were the summer residences of Dr. Julius C. Bierwurth, Dr. Charles J. Duffy, and Dr. Antonio Fanoni. The cottage seen here was built for Dr. Fanoni, a New York City surgeon and philanthropist. His plot purchase consisted of 20 building lots, each measuring 20 feet by 100 feet, on Laurelton Boulevard between Penn and Beech Streets. Dr. Fanoni had his sandy tract landscaped to create a graceful, sculpted front entry and rear formal gardens reminiscent of those in his Italian birthplace. This richly verdant spot cultivated at a time when little foliage could be found in Long Beach created quite a sensation. Dr. Fanoni named his retreat Villa Modestina, and though it stands no longer it is well remembered as the subject of many photographs and postcards. (Courtesy of Herman Druckman.)

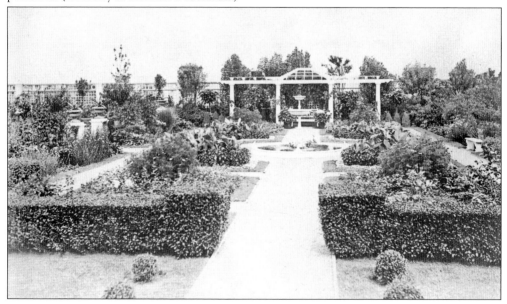

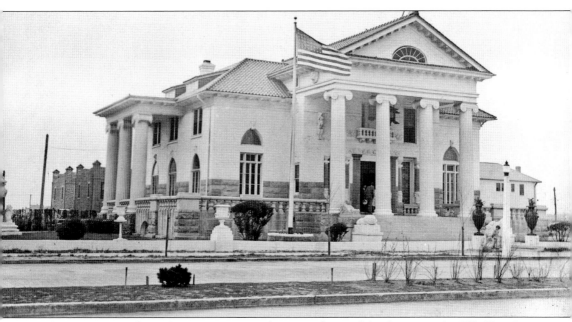

Another of Long Beach's earliest mansions was this magnificent edifice known as the "Idle Hour." It no longer stands at the corner of Washington and West Beech Streets, but continues to hold a place in Long Beach history. Some say that Silver Dollar Smith implanted silver dollars in the floor of the foyer. While under the ownership of Arnold Rothstein's syndicate, it was noted as a place of entertainment and gambling. Rothstein gained notoriety as a central figure in the infamous Chicago "Black Sox" bribery trial of eight 1919 White Sox World Series players. In 1933, architect Richard A. Gebhardt redesigned the "Idle Hour" for use as a house of worship for the congregation of St. John's Lutheran Church by the Sea—the time period of this photograph. In later years, it became the site of the Pride of Judea Orphanage.

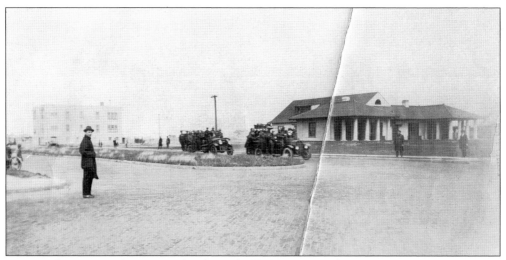

In 1913, the Estates of Long Beach achieved official status as the Village of Long Beach. The action was prompted by the desire for a school district independent of the Oceanside Schools. A casual form of municipal government was established, and lacking an official facility in which to hold meetings, the village board utilized the primitively-built Long Beach Yacht Club located at the bayside and Magnolia Boulevard. A more suitable village hall was created by moving the Estates of Long Beach sales building, seen above, from its site at the boardwalk to Park Street just west of the railroad station. A new yacht club opened in 1922 to host yachting races up until World War II when the U.S. Navy conscripted yachts. Following the war, it was converted to a summer theater, nightclub, and boxing arena. (Below, courtesy of Mark McCarthy.)

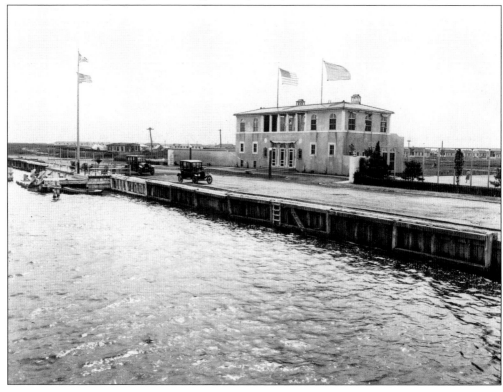

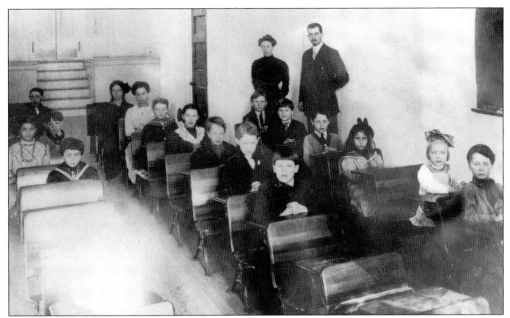

Long Beach Estates' children attended school along with the children of laborers in this one room of the Nassau Hotel. Their teacher, Minnie B. Atkins, was supervised by the Oceanside Schools superintendent, R. L. Weaver. Minnie Atkins was revered as a teacher for many years as evidenced by dedications in high school yearbooks. The children's names are listed on the back of this 1912 photograph archived by the Long Beach Historical Museum. Among them are children of the Snow, Murtha, and Wright families. As the number of children living in the community increased, the one-room school at the Nassau Hotel no longer sufficed. The photograph below is of the first multi-classroom school. The village rented the second floor space in this building on Park Street between Park Place and Riverside Boulevard.

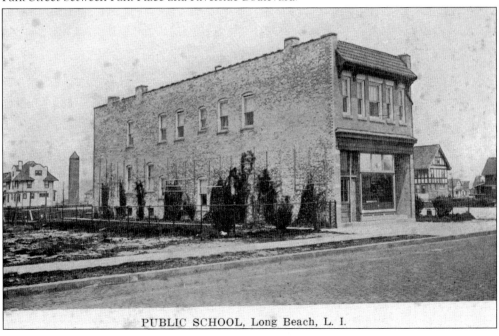

PUBLIC SCHOOL, Long Beach, L. I.

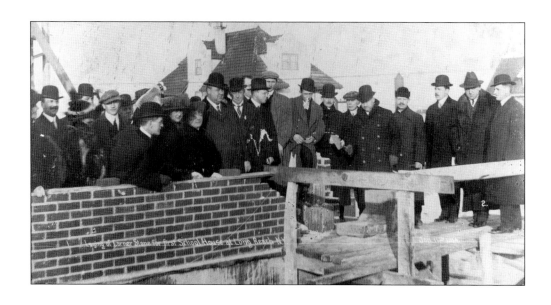

On January 11, 1914, the distinguished village leaders laid the cornerstone of the first school to be built in the new school district number 28. The school was located on Park Street near the corner of Magnolia Boulevard. The school became known as the Magnolia School and housed all grades. Two wings were added to accommodate increased enrollment. It became a junior/senior high school when West School was built in 1925 and East School in 1927. In 1929, another wing was added at the corner of Park and Magnolia Streets to serve as the Central High School. In 1946, the east wing of the Magnolia School was razed to create a playground for the high school. Central School has been converted to condominium apartments, and its parking lot occupies the remainder of the Magnolia School site. (Courtesy of LBPL.)

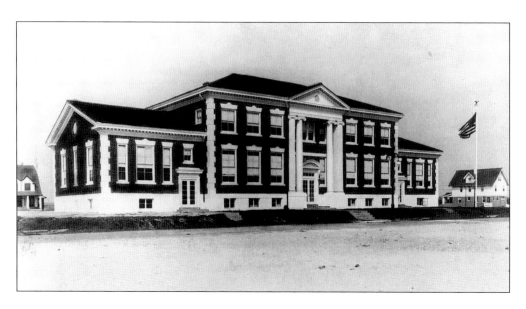

In 1914, Long Beach Village still had plenty of lots to sell and continued to reach out for an exclusive population. The sales force of the Estates of Long Beach actively appealed to wealthy New York City residents as well as those in surrounding environs. Reynolds's original concept of artistically designed brochures on glossy, high quality paper served as the basis for the advertising campaigns. As in the early years, costs of publication were funded by the full-page advertisements of various city establishments. These advertisements, such as those seen here, now tended to specifically address services for the Long Beach populace rather than those of earlier brochures, which were sponsorship advertisements from well-known New York City establishments.

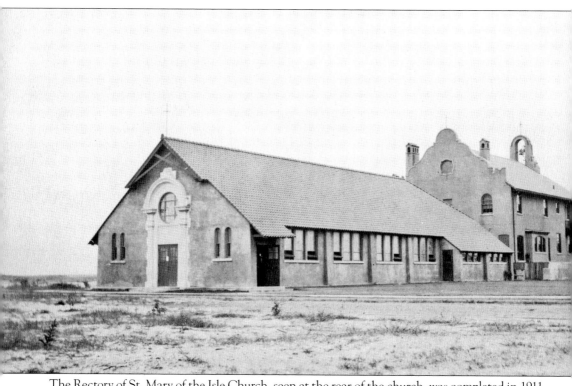

The Rectory of St. Mary of the Isle Church, seen at the rear of the church, was completed in 1911 as the summer retreat of Monsignor George Mundelein of the Catholic Diocese of Brooklyn. Its mission-style bell tower was a navigation aid for ships approaching New York Harbor. A makeshift chapel was created in the garage to accommodate Catholic summer guests and hotel employees who were transported to Sunday mass by the railroad bus. By 1915, it was inadequate to meet the need, and the diocese was prompted to build St. Mary of the Isle Church. The 300-person-capacity church is noted for the beauty of its stained-glass windows. As a summer church, it began by having mass said each Sunday by priests vacationing in Long Beach. That practice continued until the requisites for a parish and pastor were met. This occurred with the expansion of summer residences into the east end of Long Beach. The growth of St. Mary's continues, as it welcomes into its fold the diverse new populace of Long Beach. (Courtesy of Mark McCarthy.)

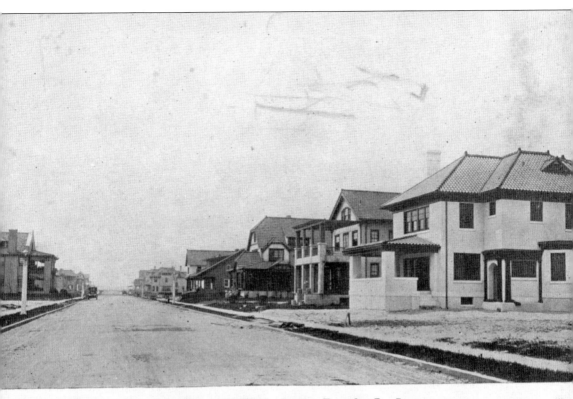

OLIVE STREET, Long Beach, L. I.

The Estates of Long Beach held title to all the streets in the village along with title to the gas franchise and the trunk sewer, which ran through Park Street. On March 13, 1915, eighty voters, comprising the total voting population, opted to bond the village for $200,000, roughly an allocation of $2,500 per vote. At the time, the village was paying $8,000 to $9,000 for the use of the main sewer and the pumping station. The funds raised by the bond issue were devoted to completing street improvements throughout the village. In return, the Estates Company turned over to the village, the title to all the streets plus the trunk sewer, pumping station, and gas franchise. The Estates Company also agreed to resurface the boardwalk. The streets and boulevards were paved with red brick with the exception of just two streets, Beech and Olive. The reason for their exception is unknown, but today Olive Street, seen in this image in its early treeless state, is one of the most beautiful of Long Beach's tree-lined streets sans red brick.

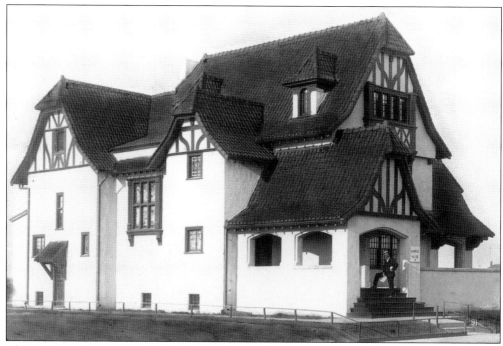

The villas and cottages of the Village of Long Beach evidence to this day the vision of an internationally styled community by Senator Reynolds. These two large villas are magnificent examples of early summer residences built to accommodate the seasonal needs of the wealthy with their entourage of family, friends, and household staff. The house in the image above is known as the German Villa, from its style, and is located on Olive Street. Not included in the photograph is the garage, a miniature replica of the house. The expansive Italianate residence seen below stands on Beech Street and is affectionately referred to as the "wedding cake house" in recognition of its many layers, which provided broad outdoor sleep porches for its summer residents. It remains as one of the few houses where the upper sleep porches have not been enclosed.

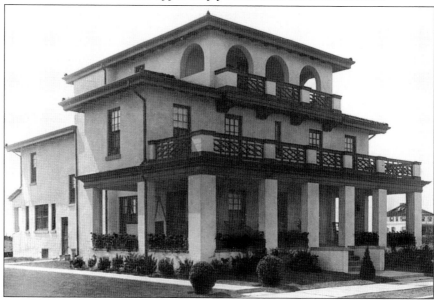

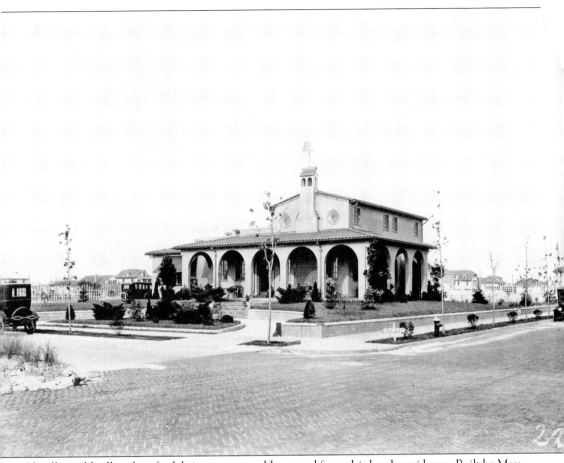

If walls could talk, tales of celebrity guests would resound from this lovely residence. Built by Max Fleischer, of filmdom fame, for his wife, Essie Goldstein, a flamenco dancer, this Mediterranean-styled villa is known today as the "Spanish Dancer's House." Fleischer and his brother, Dave, were early developers of animated cartoons. Max brought Betty Boop to film fame by taking an original Grim Natwick cartoon of a dog named Betty Boop and changing the character to the still popular flirty girl. He also brought Popeye and Superman to the screen. Cab Calloway, who also summered in Long Beach, was often a guest, and his music was used in some of the Betty Boop cartoons. The furnishings and kitchen built-ins were mini-sized to accommodate Essie's tiny stature. The basement housed a retractable stage, and its wine cellar door was a replica of the solid, carved Mediterranean-style house entrance door. The exterior of the home was originally white stucco but is now brick-faced. The enclosed upper level was an open terrace where the village children were often invited to view cartoon films. (Courtesy of Mark McCarthy.)

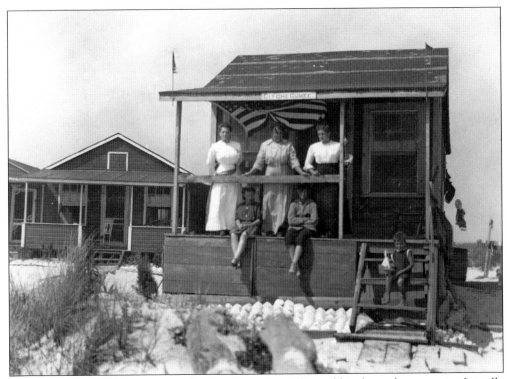

Long Beach's west end grew up completely independent of Reynolds's planned community. Initially the community was composed of shacks that often would be picked up and moved at the resident's whim or feeling of being encroached upon. These highly flammable structures existed without waterlines or firefighting equipment. What their residents had was an alarm bell, which brought out everyone the day they proudly raised it up onto a tall pole so that in case of fire its sound could be heard from ocean to bay. When the alarm rope was pulled, the entire community would turn out to fight the fire. It was not easy. Even though they were surrounded by water, there was none in immediate proximity. Bucket lines to and from either the ocean or bay would be formed, but all too often fire took its toll.

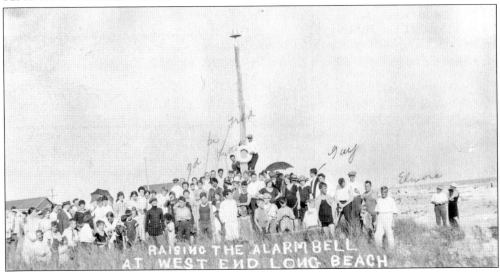

RAISING THE ALARM BELL AT WEST END LONG BEACH

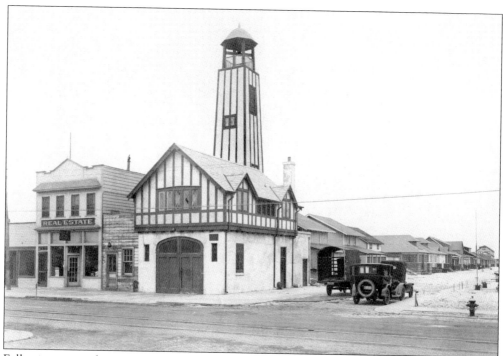

Following years of going without protection from fires, the property owners and residents of the West End brought about the incorporation of the Long Beach West Volunteer Fire Department in 1920. Upon becoming a part of the enlarged Village of Long Beach in 1921, this heretofore, neglected community received from the village a new American La France fire engine and a suitable engine house. The tower could be seen for miles out to sea and was a navigational landmark. The firehouse soon became the center of West End life, as a social gathering place for all ages. A gym in the tower often featured Golden Gloves boxing exhibitions along with training sessions. In 1928, the city of Long Beach built a modern structure to replace the old firehouse, a part of which remains today as a hair salon. (Above, courtesy of Mark McCarthy.)

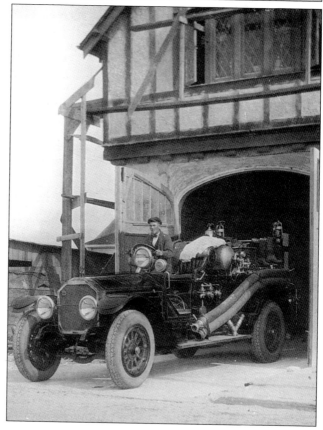

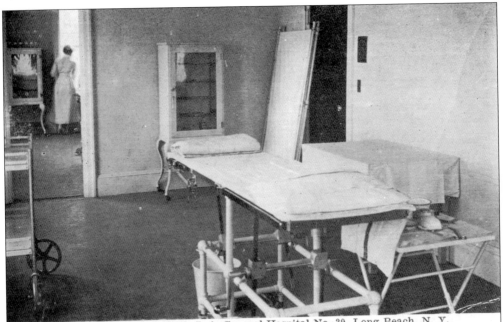

OPERATING ROOM, U. S. A. General Hospital No. 39, Long Beach, N. Y.

World War I brought great change to Long Beach when the Nassau Hotel was conscripted by the army to serve as a military hospital. Seen here is one of several operating rooms housed in what were guest rooms, while patient wards were set up in larger quarters such as the dining halls and ballroom. The hospital's military personnel were housed in barrack-type bungalows barged from Camp Yapank and reassembled.

The area between Lindell and New York Boulevards was within walking distance of the military hospital, so the reassembled barracks were placed back-to-back along narrow lanes. This created a unique neighborhood of 10 lanes named for months of the year and known today as "The Walks." It has no access for cars, and all deliveries must be hand-trucked or carried from the streets or boulevards that border it.

78

As World War I ended, the up-to-then haphazardly built west end of Long Beach began to bud as a summer community. Spurred by Joseph Day's successful auction sales, Reynolds and his realtor friends, the Walsh Brothers, convinced Milton Kolb, a prefabricated bungalow developer, to build in Long Beach. He constructed his New Yorker, California, and Pennsylvania style prefabricated bungalows on the first three West End blocks. Another developer, Brooklyn lumberman Louis Bossert, built his style of bungalow on lots purchased at auction. To spur sales, he built one at the boardwalk, as seen here. In 1925, the village annexed the community extending its western border to Nevada Street. In looking toward Long Beach as a city, Reynolds kept his eye on the burgeoning neighborhood, for he knew, as he later professed to its residents, "It's no city without you West End!" (Below, courtesy of Grant Geidel.)

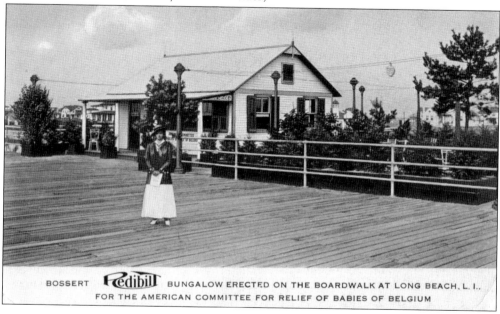

BOSSERT **Redibilt** BUNGALOW ERECTED ON THE BOARDWALK AT LONG BEACH, L. I., FOR THE AMERICAN COMMITTEE FOR RELIEF OF BABIES OF BELGIUM

In 1921, the U.S. Census Bureau discovered that the Village of Long Beach was not included in the 1920 census. It was the only community in the nation left out of the enumeration. The bureau hurriedly appointed Minnie Barriscale, wife of police captain Walter Barriscale, to conduct the count. Although several thousand persons spent their summers at the village resort, the count showed a resident population of 407 people. (Courtesy of Dorothy Barriscale.)

In 1923, a cheerful hardworking group, under the chairmanship of Minnie Barriscale, tagged automobiles for two days and raised $1,500 for the hospital fund. These ladies attired in the "raiment of mercy" were also instrumental in the accumulation of $25,000 in a five-day Mardi Gras event on the boardwalk. Included in the activities were a raffle of Liberty Bonds, a children's parade, and a popularity contest. (Courtesy of Dorothy Barriscale.)

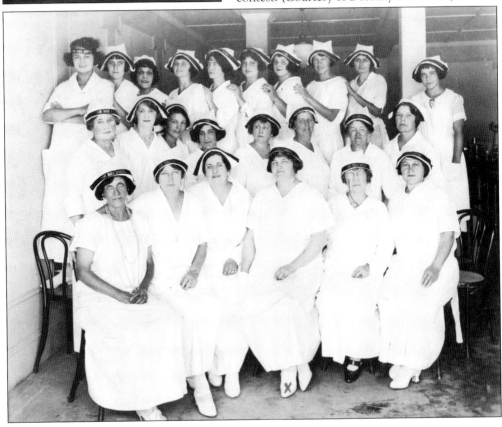

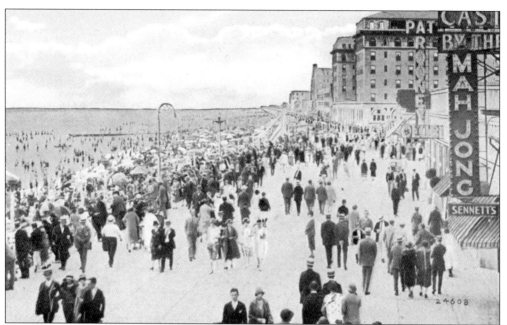

The end of World War I brought the return of the "good life" to Long Beach. People looking for entertainment and amusement came in droves, and the boardwalk became again the place to promenade. The Nassau Hotel returned as a leading hotel. Pat Rooney Jr., the noted song and dance man of vaudeville, opened a club where he and his wife, Marion Bent, were the star performers.

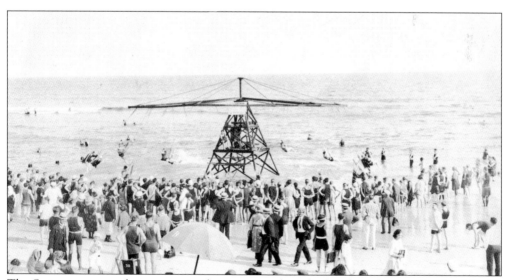

The Swing, an unusual amusement ride, was erected on the beach at the water's edge. Usually seen at amusement parks such as Coney Island's Steeplechase, the beach locale was seen as one where people in beach attire would more likely buy a ticket for the ride. It was also purported that in case of an accident, landing in the shallow water was preferable to hitting one's body on a hard surface. (Courtesy of Mark McCarthy.)

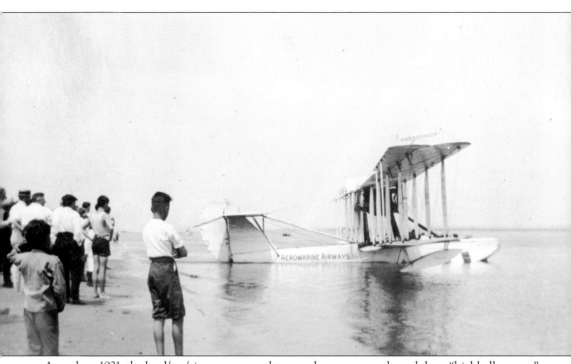

As early as 1921, the land/sea/air concept caught on and resort areas adopted these "highball express" transporters. Long Beach was host to one, American Aeromarine Inc., as part of their route No. 3, which also serviced the Hamptons. The one-way fee to travel between Long Beach and New York City's West Eighty-Second Street pier was $20. However, the company's brochure informed the traveler that "many men of affairs now make daily trips to their waterside homes or to their golf courses in the luxurious cabin of an Aeromarine Flying Boat. What used to be an hour of grime coupled with traffic holdups is now 20 fleeting minutes of safe restful pastime." Aeromarine Airways thrived in the comfort of Long Beach as a safe harbor. Its Long Beach docking site was in Reynolds Channel, just northeast of the yacht club. In 1925, the company's operation was privately taken over to become the Long Beach Seaplane base. Some form of excursion continued until the 1970s when sharing the bay became no longer safe for two modes of navigation.

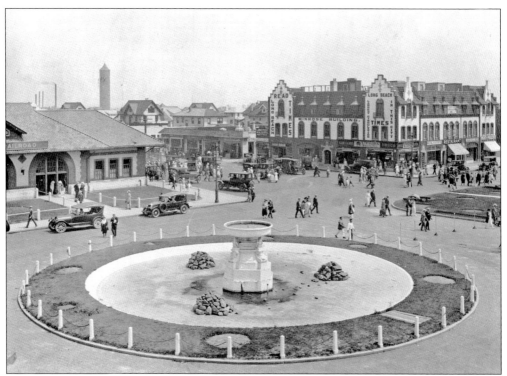

Ever the showman, with a flair for dramatic salesmanship and with great power as the village board president, Senator Reynolds, as he did with his Coney Island Dreamland, created a sensation with his awe-inspiring electrified fountain placed in an attention-getting traffic circle in the center of the village. This was no ordinary water fountain, rather one that drew crowds who delighted in the dancing waters lit by colored incandescent bulbs—an uncommon village center to say the least. Its placement directly across from the railroad station served to entice the visitors as they entered the village to reflect upon Long Beach as having a growing innovative future worthy of their investment. The image seen below of a 1930s lass is of a later period but clearly illustrates the fountain's sculpted details and magnitude. (Above, courtesy of Mark McCarthy; right, courtesy of LBPL.)

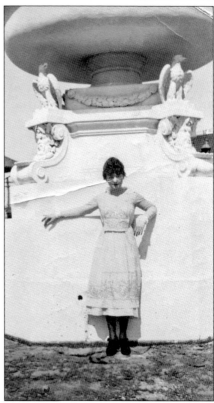

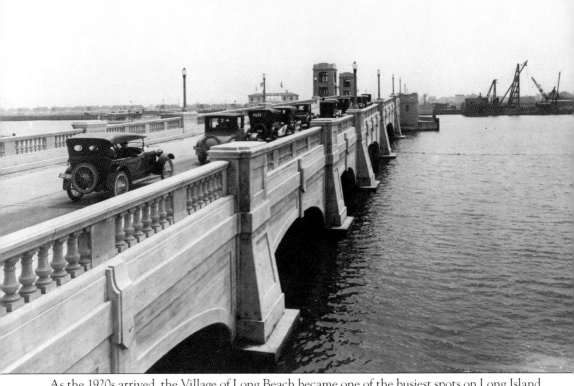

As the 1920s arrived, the Village of Long Beach became one of the busiest spots on Long Island. Only a mere 10 years had elapsed since Senator Reynolds began his development of a barren sandbar with little in its favor except a wonderful beachfront. Coincidently with the removal and modification of construction restrictions, there were the two large auction sales held by Joseph P. Day at which several thousand lots were sold to homebuilders. A population boom was occurring, and to any observer it was evident that the wooden trestle bridges no longer sufficed as passage for the number of vehicles seeking to cross Reynolds Channel. The village board submitted a proposal to Nassau County for the construction of a concrete bridge. The county allocated $1 million to build a concrete automobile bridge across Reynolds Channels, connecting Austin Boulevard in Island Park with Long Beach Boulevard in the Village of Long Beach. By the time the bridge was opened for traffic on May 1, 1922, the village had gained, on April 13, a New York State charter, incorporating it as the City of Long Beach. (Courtesy of Mark McCarthy.)

Five

THE CITY
BY THE SEA

A most important event in the history of Long Beach occurred on the weekend of May 28, 1921, when Joseph P. Day sold at auction a total of 2,046 lots for $2,066,460. Senator Reynolds declared the spirited and eager bidding an indication that through this means, 5,000 more people would increase the Long Beach population within the next year. He was proven right by an immediate period of rapid development.

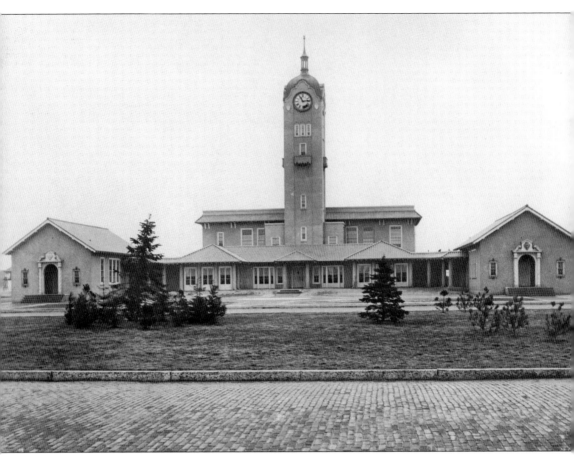

The height of Senator Reynolds's political achievement is evident in this image of the first city hall, with the police department to the right and the municipal court at the left. It is here that Reynolds reigned after besting Albany politicos, such as Alfred E. Smith, through political machinations and gained the incorporation of the City of Long Beach on April 13, 1922. Following a contentious campaign against Charles Gold, he was elected mayor by a landslide on May 16, 1922. The City of Long Beach officially began operation on June 1, 1922. Reynolds was so endeared by the citizens of Long Beach that when he was taken off to jail in 1924, they stopped the city hall tower clock until he returned. He was charged with embezzlement but was exonerated by the state court of appeals in 1925. The symbol of the clock frozen at 3:30 was later adopted as part of the city emblem. This picturesque city hall was razed, and in its place rose the new city hall, a six-floor 1960s brick and glass structure. (Courtesy of Mark McCarthy.)

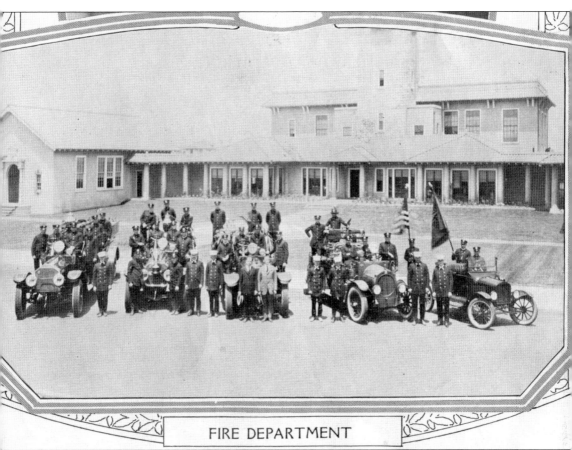

FIRE DEPARTMENT

The Long Beach Fire Department, seen here in 1923, was organized three years prior to the incorporation of the Village of Long Beach. The members were the wealthy residents of the community. In 1912, Edward F. Croker, former chief of the New York City Fire Department, was elected "Generalissimo" and was empowered to select an appropriate uniform. He chose "black trousers, which will go with evening dress, blue shirt, and red helmet. The trousers can be worn to social functions in the evening, and in case of an alarm the members would not have to go home to dress before responding." Croker averred that he personally would not need the department's services because his house from cellar to garret was solid concrete. Carpet and furniture covers were of asbestos, while furniture, doors, and trimmings were metal. Indeed, he was given to demonstrating his home's fireproof qualities by setting a pile of flammables afire as after-dinner entertainment. The firefighting equipment was several hand hose carriages installed in portable houses on the beach to which Croker added a $4,000 fire truck.

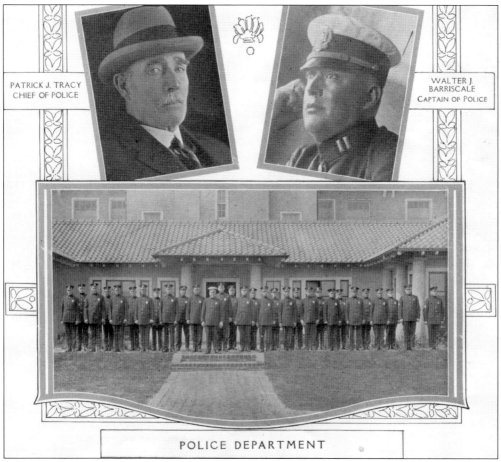

PATRICK J. TRACY
CHIEF OF POLICE

WALTER J.
BARRISCALE
CAPTAIN OF POLICE

POLICE DEPARTMENT

The history of the Long Beach Police Department reaches back to Senator Reynolds's first ventures on the sandbar. Cognizant that the safety of all who came to see, live, or play was paramount to the success of his undertaking, he initially established a small constabulary of cottage owners to help maintain order and observance of his restrictions. A more formally organized police force was organized when the village was chartered, and Patrick J. Tracy and Walter Barriscale, seen here along with the department in a 1923 photograph, were appointed to head the department. Both men continued in their positions when Long Beach became a city in 1922. It has been reported that, over the years, Chief Tracy wondered how he could put into effect a rule that would not be too puritanical and which at the same time would control the alluring qualities of beach life. In 1922, he decreed that Long Beach bathers of the opposite sex must keep at least 6 inches apart and had his patrolmen walk the beach with tape measures to enforce that rule.

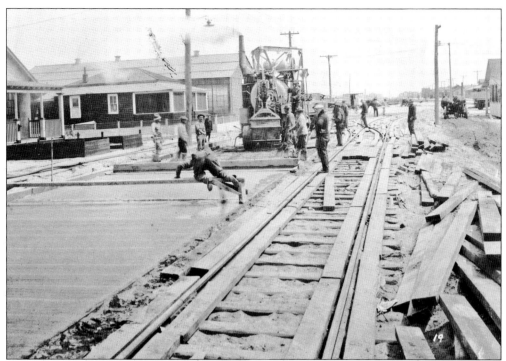

Reynolds mayoral campaign included a promise to bring a "10 cent trolley line" to the city. On June 10, 1922, he announced the routing of a gasoline-operated passenger car line over 80 pound tracks that were to be laid along Park Street and through the West End along Beech Street. These "trolleys" replaced regular buses and connected directly with the Long Island Railroad Station. They were operated by Reynolds-owned Long Beach Railway Company until 1926 when Frank Frankel bought both the Long Beach Bus Company and the Railway Company for $200,000 and thereby gained entire control of all the transportation lines except taxicabs. On August 13, 1929, a huge funeral pyre of four trolleys was lit under the supervision of the fire department. The entire stock, carbarn, and tracks included, were later removed under agreement between the bus company and the city. (Above, courtesy of Thomas J. Mulligan.)

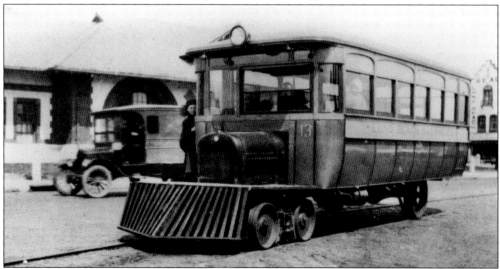

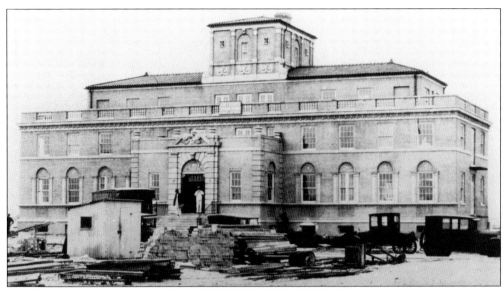

The well-being of beachgoers and Long Beach residents was safeguarded in 1922 by a small group of medical personnel assigned to a first aid station in a tent on the beach. Such was the beginning of Long Beach Memorial Hospital, pictured here in 1925 on its East Bay Drive site, which was donated by then-mayor Reynolds. Dr. George Reiss, city health officer, threatened to leave the community unless a hospital was built. The entire community banded together to raise funds and brought the circus to town, parading on the boardwalk with Will Rogers, Eddie Foy, and the Seven Little Foys. The event raised $10,000 and was the first of many that over the years made possible the purchase of ambulances and equipment, along with building expansion projects. Today Long Beach Medical Center is a comprehensive medical complex. (Below, courtesy of Dr. Marvin Alterman.)

The H. V. Snow Company was the first plumbing concern to establish in Long Beach prior to the city being chartered. The firm's telephone number, as seen in this ad, was "Long Beach 1." As the city grew, the business soared with it and continued as a reliable firm following the death of Howard Snow in 1937. Members of the Snow family continue to serve Long Beach as plumbers.

Plumber Howard V. Snow was a successful businessman and prominent citizen in 1922. When Mayor Reynolds appointed his city hall officials, he naturally chose Howard Snow to chair the Examining Board of Plumbers. In that capacity, Snow wrote the city's plumbing code with the assistance of his board colleagues, in particular health officer, Dr. George Reiss. Snow also served as the first fire chief of the city's new volunteer fire department.

ISN'T IT ABOUT TIME

you planned to have that outdoor job of Plumbing done? Let us talk the matter over with you and give you our estimate on

RELIABLE PLUMBING.

Installation of New Plumbing, Plumbing Repair Work, Outdoor Plumbing, or Inside Work can be safely entrusted to us.

H. V. Snow Co., Inc.

16 East Park Street Phone Long Beach 1

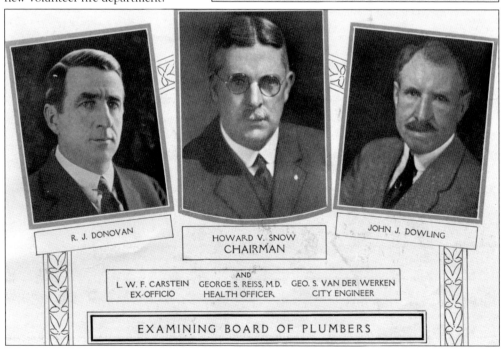

R. J. DONOVAN

HOWARD V. SNOW
CHAIRMAN

JOHN J. DOWLING

AND
L. W. F. CARSTEIN GEORGE S. REISS, M.D. GEO. S. VAN DER WERKEN
EX-OFFICIO HEALTH OFFICER CITY ENGINEER

EXAMINING BOARD OF PLUMBERS

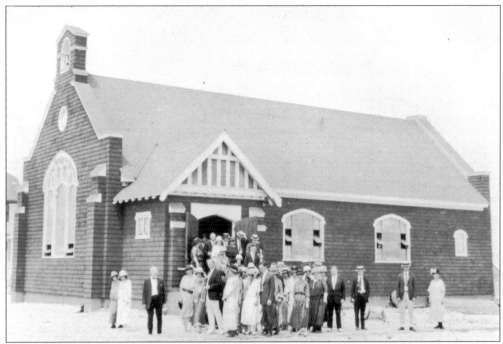

On June 3, 1920, a group of Christian Protestants organized to build a nondenominational church located in the West End. Despite financial setbacks, the small congregation gained a charter in 1921. Greater fund-raising efforts resulted in the purchase of land on Delaware Avenue at the bayside. The cornerstone of the church was laid in 1922. The following year, Mayor Reynolds donated the greatly admired "The Good Shepherd" stained-glass window.

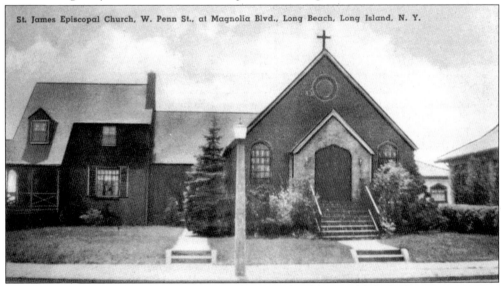

St. James of Jerusalem Church, built in 1935, is home to the oldest established religious community in Long Beach—dating back to 1880. It has the distinction of being the first Long Beach building designated as a local landmark. The former pastor, Martin Bowman, curated a collection of religious icons and paintings that are on view in the church. Note the original Penn Street lamppost in front of the church. (Courtesy of Doug Sheer.)

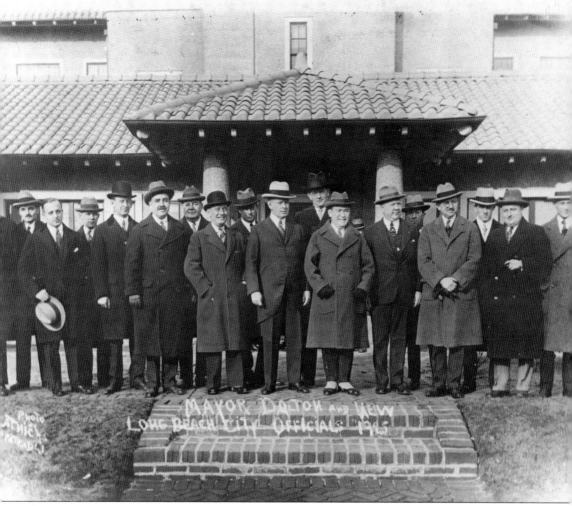

The mayoral election of 1925 came to be known as the "Campaign of Legal Maneuvers." When Reynolds was jailed, Frank Frankel became the acting mayor and would run as the incumbent in 1925. The plan was for Reynolds to also run as a candidate on the Loyal Citizens Party line and then have Frankel step aside and endorse Reynolds. The Citizens and Taxpayers Association along with the West End Civic Association and both the regular Republican and regular Democrat organizations endorsed William J. Dalton's candidacy. Seeking to head off the Republican/Democrat endorsement, Frankel entered the primaries of both parties. Dalton challenged Frankel's petitions and won in state supreme court. However, the court allowed both to enter the primaries of both parties. Dalton, a registered Republican, lost the Republican primary but won the Democratic contest. Frankel, a Democrat, lost the Democratic primary and won the Republican primary. Meanwhile, the Alfred E. Smith Democratic Club was formed and endorsed Martin McHale. Mayor William J. Dalton won by 154 votes. He is seen here seventh from the right among his city officials. (Courtesy of LBPL.)

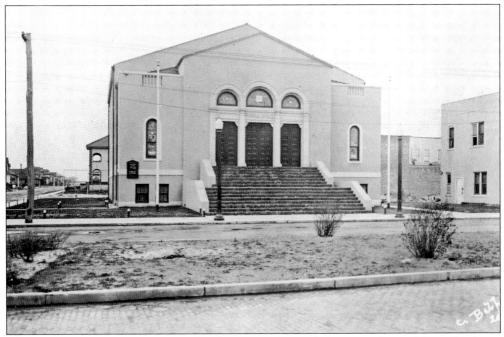

In 1922, the first Jewish synagogue, the classic Temple Israel, was erected on a 5-lot-wide plot at the corner of Riverside Boulevard and Walnut Street. In the years following its first 1923 services, the congregation's growth reflected that of the city, and by 1930 the need for a school became evident. The Talmud Torah building was erected on Walnut Street. A social center onto Park was a later addition. (Courtesy of Mark McCarthy.)

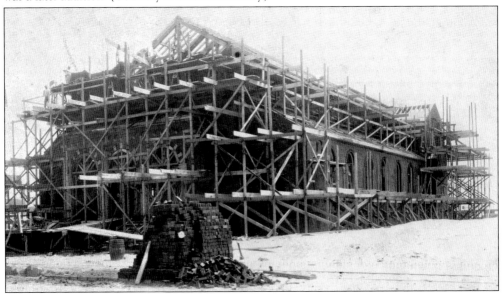

The construction of the cathedral-like structure of St. Ignatius Martyr Parish Church began in April and was completed in October 1926, fulfilling the dream of its pastor, Father Edward Hoar, who had established a summer mission in the West End in 1918. The word went out that the congregation would be out of the movies (West End Theater) and into the church by Christmas. The first mass was said on December 11, 1926.

The National Bank of Long Beach, housed in this building on Park Street just east of Edwards Boulevard, was authorized to open for business on June 17, 1920, with a capital of $25,000 and a surplus of a similar amount. In 1926, it changed its form of organization and became a trust company known as the Long Beach Trust Company. It grew to be the second largest trust in Nassau County.

Unable to meet its obligations in 1931, Long Beach Trust announced its closing. This created fear among the depositors of its competitor since 1927, the National City Bank of Long Beach. A run on both banks started, but Mayor Frankel quelled the crowd at National City by assuring them, "Your money is perfectly safe here." The trust closed, and the building was converted to use as the public library until 1945. (Courtesy of LBPL.)

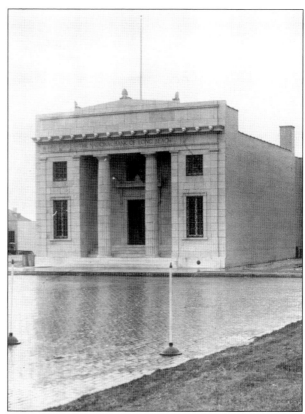

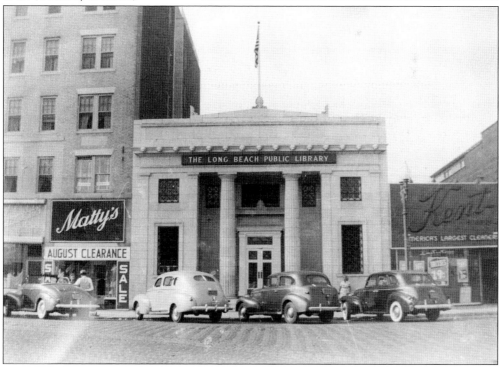

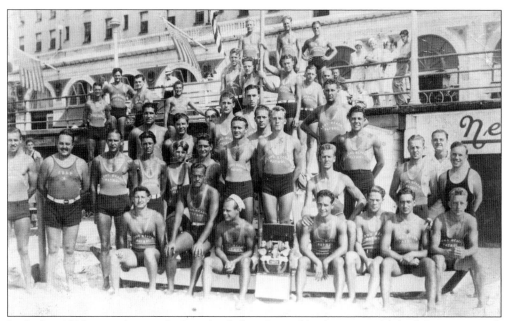

In the late 1920s, upon buying the boardwalk from Reynolds, the city established the Long Beach Patrol to protect the residents and visitors who now had easy access to the beach park. Up until that time, each bathhouse and hotel hired lifesavers for its beach. The patrol has evolved into a summertime career for teachers and, along with the city's school and recreation swim programs, has greatly improved the quality of lifeguards.

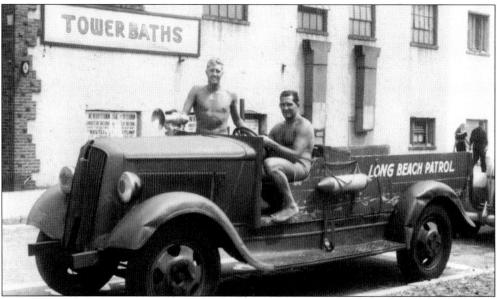

Lifesaving equipment such as this "super high speed emergency vehicle" driven by Paul Boesch with John Birkholz, has been continually updated to that of today's torpedoes, surfboards, wave runners, handheld radios, and telephones. Long Beach has implemented stricter standards than Nassau County's by requiring its lifeguards to swim faster and complete a 2-mile run. Today's lifeguards are knowledgeable about the ocean environment and are often graduates of the junior lifeguard program.

TOWER BATHS, BOARDWALK AND NATIONAL BLVD., LONG BEACH, L. I.

80

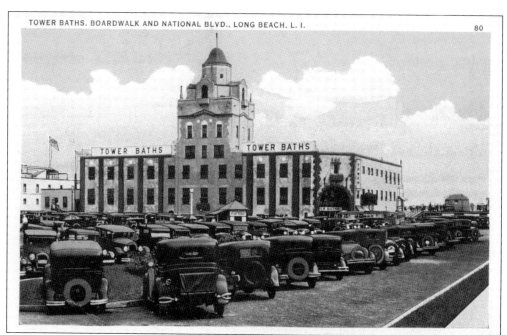

For more than three decades, Tower Baths stood on one of the most historic Long Beach sites. Just as it filled the block of National Boulevard from the boardwalk to Broadway, so did the Long Beach Inn, Nassau's tennis courts, and the music pavilion. It was destroyed by fire in the early 1960s, along with several of the most popular boardwalk places, Izzy's Knishes, Faber's Skee-Ball, Kalin's Frozen Custard, and the arcade. (Courtesy of Doug Sheer.)

Tower Baths provided its patrons with locker facilities, private shower rooms, and bathing suit rentals. To earn money for college, Carol Spielberg worked as a locker room attendant and, contrary to some others, conscientiously washed out the returned suits before hanging them to dry. The tax on the sign refers to a 25¢ beach use fee levied by the city when it took over the beach park from Reynolds. (Courtesy of Carol Spielberg.)

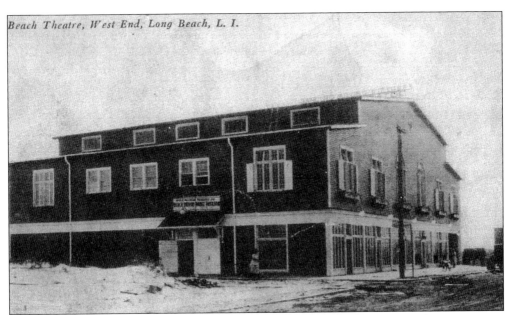

The West End movie house was a local, summertime only venue without air-conditioning except for two large fans and open doors at both the rear and side of the building. Youngsters referred to it as "The Itch," but were always eager to climb up onto the metal fence at the rear and watch the movie until the manager gave chase. The "Itch Wagon" would cruise through the streets ringing a bell activated by a long pull cord attached to the car radiator. A billboard was attached to the roof showing the movie of the day while local youngsters, who were each given one free pass, passed out circulars of coming attractions. The picture below informs that not only were movies shown in Long Beach, they were filmed here too, and the elephants starred again.

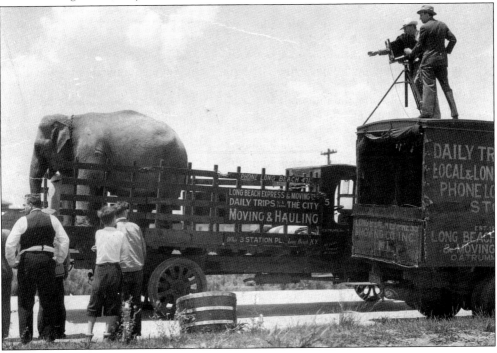

Throughout Prohibition, Long Beach was infamously known as a safe harbor for rumrunners acting without fear of being charged with violation of the Volstead Act. The Long Beach community and its officials were inclined to "look the other way" when bootleggers' cargo was unloaded into trucks for delivery to New York City and the 28 speakeasies along West Beech Street. In essence, Federal agents and the Nassau Police could not rely upon commissioner Grossman's police to investigate or conduct raids because they were suspected of and later charged with "being on the take." The raid pictured above occurred at Riverside Boulevard and the bayside while other raids were carried out at the Nassau Hotel, Lafayette Hotel, and Castles by the Sea. The raid seen below occurred in Shines, the only West End speakeasy that remains today as testament to that bygone era.

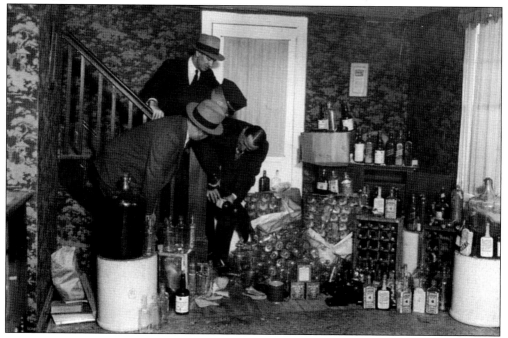

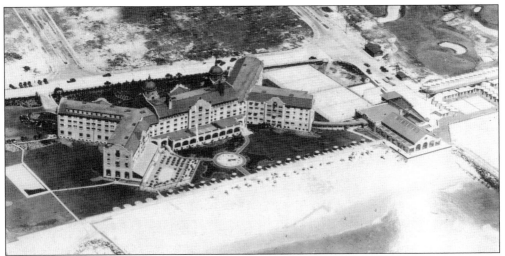

In 1929, Reynolds reached his zenith for Long Beach, the ultra-elegant Lido Hotel. The project cost him dearly, for prior to construction he had refused an offer of $50 million for the property. During construction, he ran out of money and had to sell his New York City property and plans for what later became the Chrysler building to Walter Chrysler. The Lido was a mammoth structure of pink concrete walls crowned by two Moorish-style cupolas. The roof of the dining room was retractable permitting dining under the stars and a sliding glass floor over the pool for dancing on water. Designed to provide luxurious leisure activities for its clientele, the hotel offered a world-class golf course, individual guest cabanas, and a boardwalk for strolling in non-beach attire. Columnists dubbed it the "smartest resort in the country."

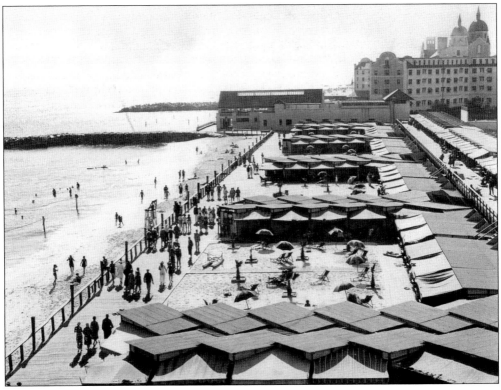

The *Daydream*, Senator Reynolds's yacht, exemplifies the extravagance and grandeur that marked the style of his work and life. This 128-foot, $500,000, custom-built seaworthy vessel succeeded his first, the 51-foot *Mull*, and the more powerful *Wanderer*, which was lost in a storm off Florida. Reynolds created a "little fleet" by adding two cabin boats and a speedboat to complement the *Daydream*. Capt. Bob King, referred to by Zane Grey as a "great guide," was in charge of this fleet berthed off of Lido in Reynolds Channel. The *Daydream*—with its nine bedrooms, seven baths, steam room, glassed-in showers, gymnasium, and elaborate salon bar—became his home on the water. It was his floating club whose members were friends and invited by personal invitation to join him for an evening's pleasure of cards and cigars or a leisurely sunset cruise. Although Senator Reynolds's residence in New York City was where he died, the *Daydream* was where he spent most of his final years. Following his death in 1931, the Reynolds estate sold the *Daydream* for $30,000 Depression-era dollars. (Courtesy of Patricia Ellis Futoran.)

This nautical painting of Senator Reynolds and his pets, Tiger and Queenie, hung in the salon of the *Daydream,* seen in the background. Reynolds is wearing the traditional yacht owner's outfit and insignia cap. Both dogs travelled with him, but only Tiger strolled the boardwalk each morning with his master and was known by all. Queenie enjoyed the more leisurely life of a pampered pet as evidenced by her bejeweled harness. (Patricia Ellis Futoran.)

Although Senator Reynolds preferred to live on his yacht, he and Elise, his wife, enjoyed the facilities of the Lido Hotel as seen here at their cabana. This photograph is perhaps one of the last of the senator, as he passed away at age 63 on October 13, 1931. In tribute, the city council proclaimed, "the beauty and symmetry of Long Beach is the heritage of his vision and genius." (Courtesy of Patricia Ellis Futoran.)

This portrait is of Starr Faithfull, whose death remains one of the unsolved cases in the annals of the Long Beach and Nassau County Police Departments. It was the basis for the John O'Hara novel and Elizabeth Taylor movie, *Butterfield 8*. On June 8, 1931, West Ender Daniel Moriarty discovered her scantily clad body washed ashore on Minnesota beach. Sensationalized stories attributed her death to mobsters, while others speculated about suicide. Her manicured nails and perfect teeth suggested affluence and led to an early identification. Her stepfather, Stanley Faithfull, identified the corpse, seen here, and subsequently was viewed with suspicion but never charged. Both Nassau district attorney, Alvin Edwards, and police commissioner, Morris Grossman, confidently proclaimed that they had the case solved and would make the name of the guilty party known the next day. The community continues to await that announcement. (Right, courtesy of artist Clementine Judge.)

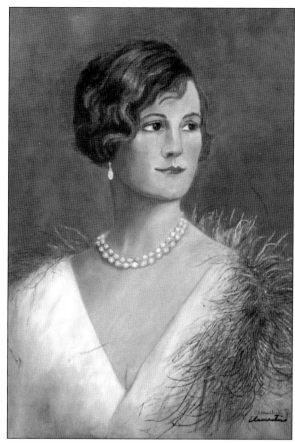

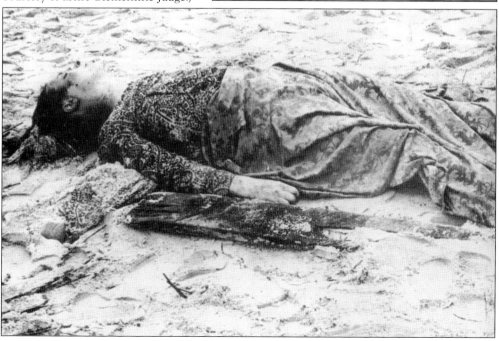

The very popular mayor Louis Edwards enjoyed entertaining celebrities who often came to participate in the city's boardwalk events. Along with other city officials, the fashionably attired, ever-smiling mayor is seen here to the right of heavyweight champion prizefighter, Jack Dempsey, as they both enjoy Long Beach's famous frozen custard. This photograph was taken on Orphan's Day in the summer of 1938.

On November 15, 1939, patrolman Alvin Dooley was on duty in this police booth at the corner of Jackson and West Beech Streets, across from Mayor Edwards's home. "Good Morning, Al," said Edwards as he walked toward the corner with his bodyguard. Dooley whipped out his service revolver, fired, and killed the mayor. An estimated throng of more than 5,000 lined the street outside of Temple Israel for the funeral of Louis Edwards.

Six

LIFE IN THE SANDBAR CITY

In the 1920s, Dr. George Reiss declared Long Beach to be "America's Healthiest City." That soon became a slogan and was often used in publications to promote the desirability of living in Long Beach. The accolade was deserved. Long Beach's healthful environment drew people to it for decades. Once they felt the sand in their shoes, they remained.

WHY LONG BEACH
IS AMERICA'S HEALTHIEST CITY

This tranquil scene is of Oceanview following the annexation of the West End. As promised by then-mayor Reynolds, the neighborhood was connected to the city's sewer, water, and electricity services. Residents experienced a radical change as real estate opportunities bloomed with summer rentals of bungalows and rooming houses. Children thrived in the safety of the new environment and those who grew up there speak of the freedom of outdoors play.

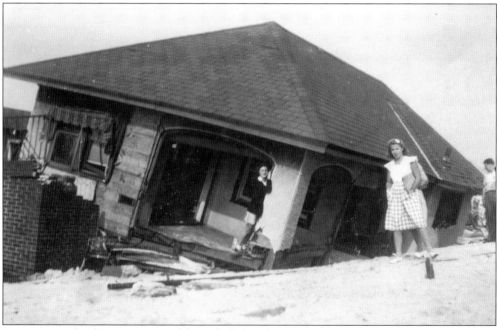

Living on an island is to experience life on the light side until nature unleashes its negative elements. In 1927, a severe storm destroyed much of the boardwalk and the Dalton administration's wood jetties. The well-remembered hurricane of February 1938, left more than 150 people homeless as houses, such as this at the ocean in the West End, were smashed or lifted and hurled by the high winds and raging sea.

A typical Long Beach "people" story is that of the youngest members of these two families, the Grays in front of their bungalow on Alabama Street, and the Silbermans in front of Orens Hotel. Audrey Gray Remo lived in Long Beach from age three; Trudi Silberman Bernstein grew up as a summer visitor. Both chose to live in Long Beach and raise their families and carve a place for themselves in the community. They met as adults in 1949 when Audrey, collecting donations for the cancer society, rang Trudi's doorbell. From that day forward a lasting friendship of mutual admiration was forged. Audrey, a middle school teacher, encouraged Trudi to pursue a teaching career, which she did. Over the years, they fostered Long Beach's charitable spirit and both have been honored for their volunteer activism by many community organizations. (Below, courtesy of Trudi Bernstein)

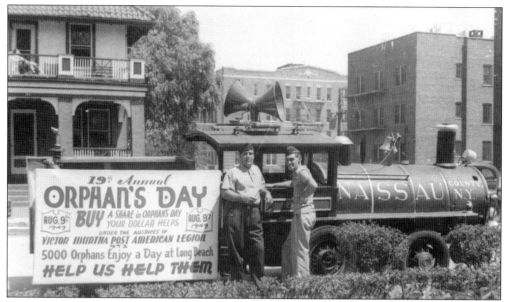

Beginning in 1930 and into the 1950s, Long Beach citizens entertained more than 150,000 Catholic, Jewish, and Protestant children at annual Orphan's Day events. Children from more than 30 metropolitan area orphanages arrived on buses, escorted by county and Long Beach motorcycle policemen. Each year, at least 1,200 volunteers, including city officials and employees, American Legionnaires, businessmen, and the Women's Democratic Club, brought the children a day of fun.

The beach and boardwalk were turned over for the children's pleasure on Orphan's Day. Ice cream, candy, and admission to the amusement centers and rides were all free. In 1951 alone, they consumed 15,000 frankfurters cooked right on the beach by Penguin restaurateur Charlie Levine. For several years, the greatest excitement was the appearance of heavyweight champion, Jack Dempsey, and the Yankees team led by Joe DiMaggio and Lou Gehrig.

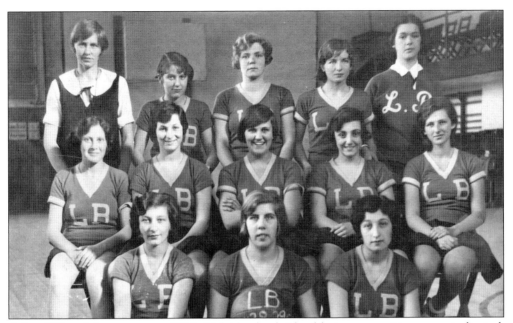

Before 1972 and the enactment of Title IX, high school girls athletic opportunities were quite limited. In the 1920s, basketball was about the only school-sponsored team sport for girls. Indeed, it is usually the only girls' team photograph found in most yearbooks of that decade. These 1928–1929 basketball team members were among the last class to graduate from the high school on Park Street near Magnolia Boulevard before it became the junior/senior high school. (Courtesy of Phyllis Wagner.)

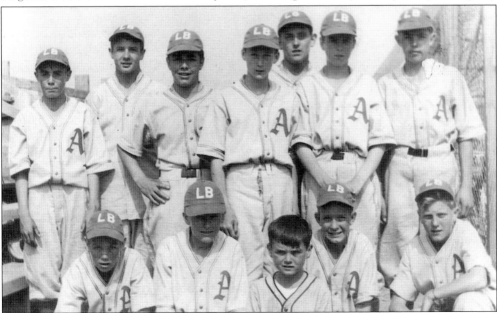

The 1930s WPA provided funds for a recreation department in Long Beach but not for a facility. Activities were offered at school playgrounds, but there were no teams or leagues. Parents who wanted more for their children organized and purchased uniforms for teams such as these Americans, a travelling baseball team. In the front row center, without a hat, is batboy Bob Carroll who became the Long Beach director of recreation. (Courtesy of Vera and Charles O'Dowd.)

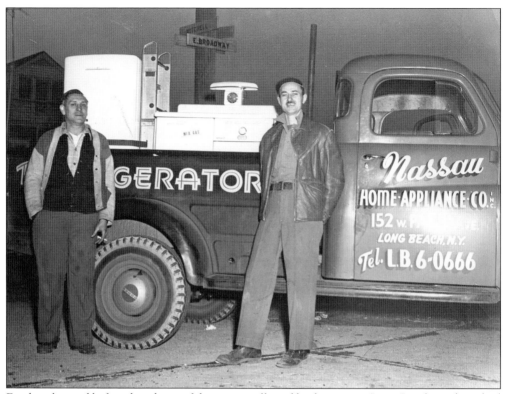

For decades, and before the advent of shopping malls and big box stores, Long Beach residents had no need to "go over the bridge." They could find whatever was needed in the way of personal or household goods right along Park Street. Nassau Home Appliance provided high quality products, "no seconds or dents here," and delivered when promised. Although no longer in business, it is wistfully and well remembered for caring service. (Courtesy of Stanley Fleishman.)

In 1938, Benjamin Sedlik combined his name with that of his wife Tillie, and founded Tilben. The business, now managed by grandson Steven, evolved from a gift and small appliance shop to one of modern electronic products. Many 1950s record collections began with a selection from its aisles. Knowledgeable photographic service has been a mainstay. Grandma Tillie lived in an apartment above the store until age 100. (Courtesy of Steven Sedlik.)

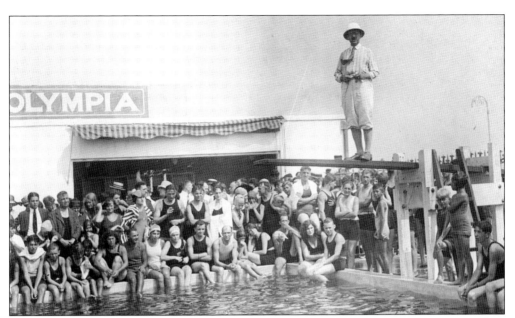

The Olympia Pool was the most popular privately owned outdoor pool in Long Beach. Quite often, swimmers had the good fortune to be displaced and treated to the opportunity to observe the practice sessions of champion swimmers and Olympic competitors such as Harold "Stubby" Kruger, Johnny Weissmuller, and Buster Crabbe. Long Beach's own Olympic star, Eleanor Holm, was a regular at the pool when her family summered in the West End.

World War II depleted the lifeguard patrol, as young men were drafted into service, but just as Rosie could rivet, Long Beach women could swim. Before being called into service, lifeguard chief Paul Boesch prepared women volunteers for their new roles. He is seen here with the women who would protect swimmers at the city's Lafayette Pool: Eleanor Armstrong, Anita Kaufman, Jo Valente, and three sisters—Helen, Joan, and Betty Smith.

The O'Rourke family has supplied the hardware needs of Long Beach residents since 1917 when Michael O'Rourke opened his store on West End's Beech Street. Through the years, the business thrived as the helm was passed first to Frank Sr. and upon his death in 1952, to his wife, Alberta, and son, Frank. Long Beachers know that O'Rourke's is the go-to place where problems and questions are expertly resolved. (Courtesy of Frank O'Rourke.)

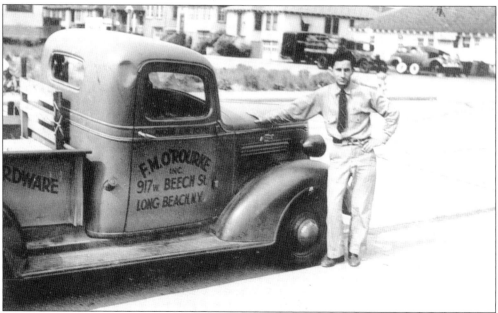

Typical of the West End entrepreneurs was Dan Evers who as a young man gained experience working at O'Rourke's Hardware from 1936 until World War II. He returned from army service in 1946 and opened a home improvement business on Beech Street in the West End. Dan's community spirit and neighborliness spurred the business to survive Long Beach's roller coaster economic cycles from the 1950s through the millennium. (Courtesy of Frank O'Rourke.)

Lumber sold by four Whitbread Family generations has built Long Beach. George Whitbread started the business on Magnolia Boulevard in 1917, with lumber and goods delivered by barge or the train on Pine Street. In 1935, the original building was moved east across the street to its present location. Pictured are George Jr., daughter June, granddaughter Christine, and in the truck, Joan, who along with her brother, Greg, operates the business today. (Courtesy of Joan Whitbread.)

Real frozen custard was a favorite on the Long Beach boardwalk, but disappeared as soft ice cream was introduced. Custard's Last Stand, not to be confused with "Custer's last stand," was deliberately located on Long Beach Boulevard just before the bridge. This was so that one last real frozen custard could be purchased before leaving Long Beach. Whether ice cream or frozen custard, it tasted best in Long Beach. (Courtesy of Stanley Fleishman.)

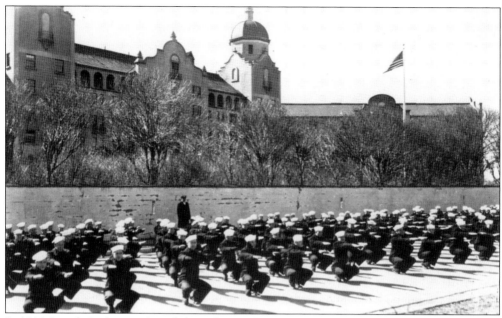

In 1942, Joseph Seiden purchased the Lido Hotel and immediately leased it to the U.S. Navy for the duration of World War II. Long Beach welcomed and entertained sailors such as those seen here in front of the Lido. The USO erected a new facility adjacent to St. Mary's Church where dances were held and many a Long Beach marriage first bloomed. That building on Monroe Boulevard is now the Community Center of St. Mary's. (Courtesy of Herman Druckman.)

The removal of the obsolete and abandoned World War II fire control tower from its site at the boardwalk took with it many fond memories of those who spent secret time in its hollow shell during their teenage years. The tower was erected as a military structure for spotters who took Azimuth Scope readings of enemy ships, transmitted to Fort Tilden's artillery, and determined if the mark was hit. (Courtesy of Dr. Kenneth S. Tydings.)

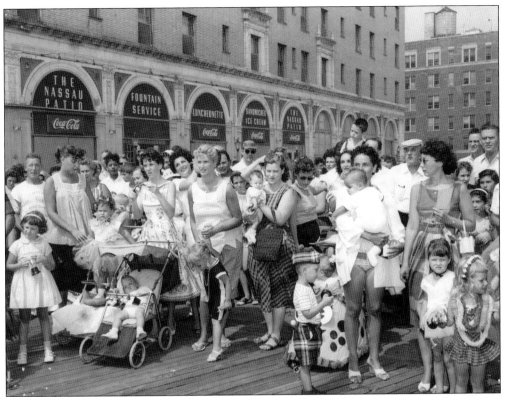

During the 1950s, baby parades and beauty contests were organized events to bring publicity and people to the boardwalks of seaside resorts. Long Beach was no exception, as illustrated by these 1958 photographs. Mothers lined up with tots in tow to wait at the Nassau Hotel for the start of a baby parade. The parades were a panorama of costumed babies and tots walking, riding, or posing in tableau with mothers hoping that their child would be chosen as the most beautiful boy or girl. Funding and support for baby parades faded in the 1960s when their effect on children was scrutinized. Beauty contests for young women continued and became part of the New York state pageant. Women waited at the Nassau to be judged, each with the hope that the stairway to fame would soon be hers to climb as Miss Long Beach.

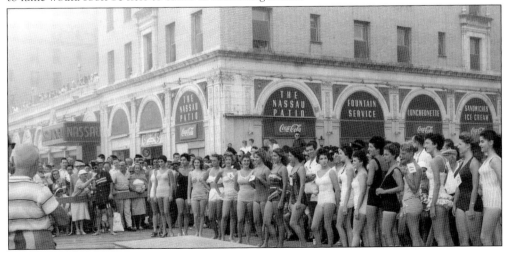

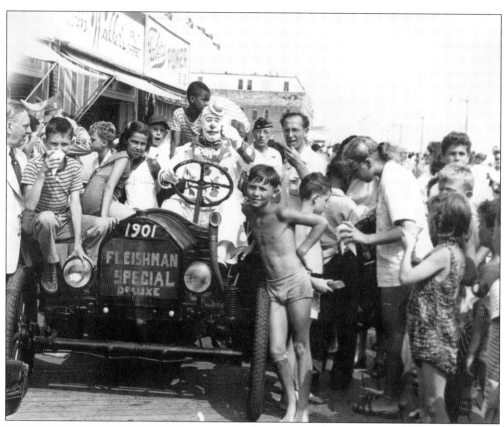

MARILYN MAXWELL

— IN —

Will Success Spoil Rock Hunter?

SAM ZERINSKY and JOSEPH S. KING, *Producers*

In the center of the picture stands Morris Fleishman, noted businessman, civic activist, and philanthropist. He started out as a bike shop owner with car sales as a sideline but soon owned a several blocks-long automobile dealership on Long Beach Boulevard. He shared his success in many ways, especially delighting children and adults alike with his 1901 Fleishman Special, a perennial sight at parades and boardwalk events. (Courtesy of Stanley Fleishman.)

After World War II, the yacht club became a venue for special events. One was the Long Beach Playhouse that catapulted Long Beach into fame as a site for summertime's Straw Hat Circuit. Show business celebrities such as Marilyn Maxwell, Bob Hope's USO star, performed in well-known Broadway plays, as did Dorothy Lamour and Robert Alda. Performers were drawn here because one could, "enjoy the beach all day and entertain to applause at night."

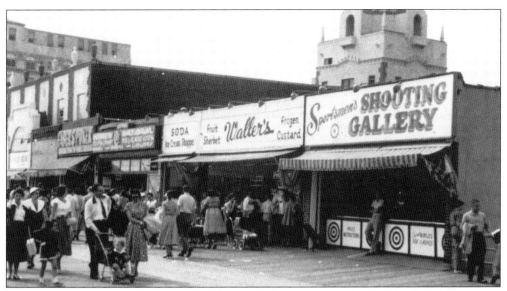

The entertainment elegance offered by the establishments along the boardwalk faded over the decades. However, crowds of people continued to be drawn to "Reynolds stage" for the populist sorts of amusement that had grown into fashion after World War II. Aspiring sportsmen were able to demonstrate their skill with a gun at the shooting gallery while other appetites were satisfied with a frozen custard at Waller's or, a little further west along the boardwalk, a hot dog at Hebrew National. In the photograph above, the tower of Tower Baths seems to be casting a bemused look upon the "nouveau" scene. The Nassau Hotel, once the exemplar of social grandeur, is seen here in the photograph below with its boardwalk entrance severely altered, topped with a blatantly nondescript sign, and abutted by Faber's Poker establishment, an amusement well remembered by many Long Beach old-timers. (Both photographs courtesy of Dr. Kenneth S. Tydings.)

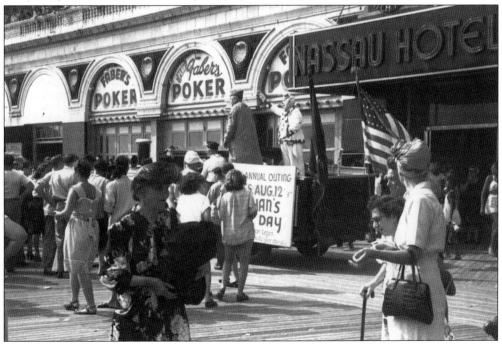

The New York Rangers and the City of Long Beach signed an agreement on July 9, 1974, under which Long Beach would provide practice facilities for the hockey team. Emile Francis, Rangers general manager, and city manager Richard J. Bowen signed the agreement. The old city skate house on Magnolia Boulevard was transformed into a locker room adjacent to the new $3-million Nassau County Arena. Eighteen Rangers lived in Long Beach at the time.

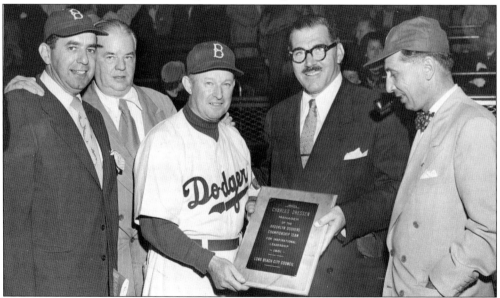

The singular honor of having, in 1951, a City of Long Beach Day at Ebbets Field, sanctifying the Brooklyn Dodgers ballpark, is commemorated here by, from right to left, councilman Morris Fleishman, city manager Maurice "Buster" Fleishman, Dodger manager Charles "Chuck" Dressen, councilman John Nugent, and councilman Fred Fell. A large majority of Long Beach residents were transplanted Brooklynites, including the city's founder, Senator Reynolds. (Courtesy of Stanley Fleishman.)

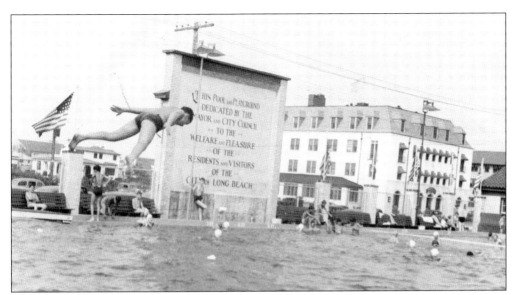

The Lafayette Pool was the first public pool built by the city. Located outdoors on Lafayette Boulevard between the boardwalk and Broadway it provided a seasonal facility not only for pleasure, but for education as well. It was there that many a child learned to swim, swim teams were developed, and lifeguards were trained. The pool was razed when all-year-round pools came into greater use at the high school and recreation center.

At Long Beach Bowl on the boardwalk, manager Flo Hausman regularly scheduled events featuring sports stars and other celebrities for the benefit of charitable organizations. For many years, champion bowler Andy Varipapa, seen here with recreation director Bob Carroll, gave bowling performances for the Association for the Help of Retarded Children. When first organizing the Special Olympics, Eunice Kennedy visited to observe Hausman's AHRC program in which disabled children of all ages had fun bowling. (Courtesy of Nick Oricchio.)

There was no mistaking Mike's Ship Ahoy Restaurant—it looked just as one might expect from its name. Located at Neptune Boulevard and Shore Road, it was owned and run by Michael Samet. Its popularity was enhanced by its direct access to and from the beach. The lighthouse seen in the photograph had a working light, which the Coast Guard found to be a hazard and ordered it shut down. (Courtesy of Joseph Ponte.)

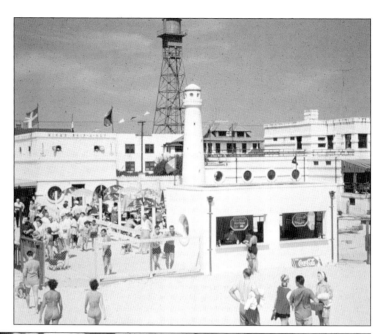

Grown-ups had their Skee-Ball, keno, and arcade games, but the amusement park rides at Edwards Boulevard and the boardwalk brought hours of delight for little Long Beach children and guests, too. There was a Ferris wheel, merry-go-round, roller coaster, and this very appropriate boat ride that is being steered by Jean and Cathy Sondergaard. Further east was an artfully laid out nine-hole miniature golf course for everyone's enjoyment. (Courtesy of Jean Sondergaard.)

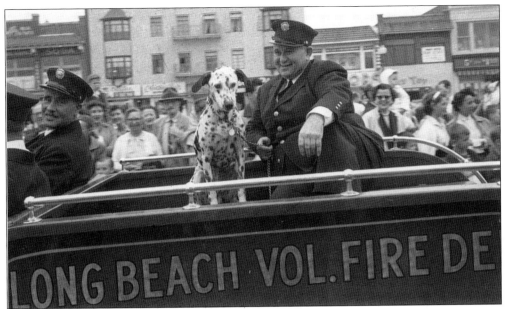

Memorial Day Parades are traditional in America, but not as likely to engender more excitement and participation as they do each year in Long Beach. The true meaning of the day is highly honored and respected, for in this twice occupied by the military city, veterans and those who gave their lives are forever held dear. To salute them, all organizations parade, including the firemen with their dalmatian and shining trucks. (Courtesy of Dr. Kenneth S. Tydings.)

The Long Beach Police Department established a motorcycle unit in the 1930s and on Albert McNeely's recommendation purchased Indian brand motorcycles. McNeely is seen here on his bike with the pigeon from a neighbor's coop that, unsolicited, flew to him each day to ride on his shoulder, with feet tucked under the epaulets. They became local movie celebrities when Pathe News featured the story of the "Motorcycle Cop and the Pigeon."

Commuting to New York City on the Long Island Railroad (LIRR) is a daily ritual for many Long Beach residents, and in the 1950s another ritual was added to the commute. Milton Ohl is seen here at his morning prayers, having devised that he could gather a minyan of 10 men to join him each morning to meet a religious obligation and not miss the morning train by going to their synagogues to do so. (Courtesy of Sheila Ohl Spiegler.)

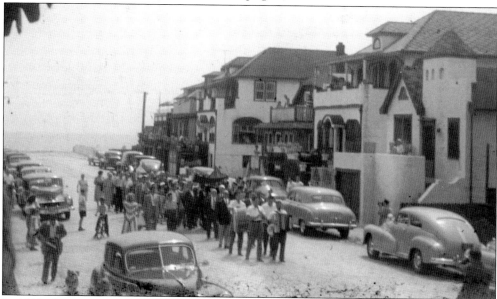

In 1948, the congregation of Temple Zion carried their Torah along Connecticut Avenue to their new synagogue on Maryland Avenue. In typical Long Beach fashion, this small orthodox Jewish congregation was warmly welcomed into the midst of its West End largely Irish Catholic neighborhood. Again in 2002, as the final letters of a new Torah were inscribed, the congregation danced in the streets in celebration. (Courtesy of Veronica Gilligan.)

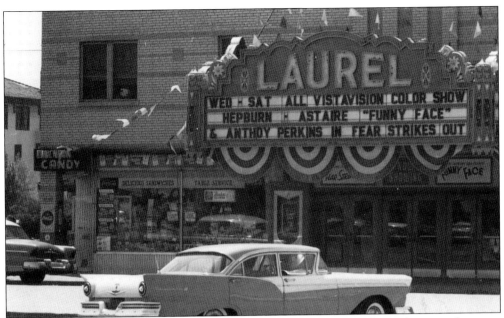

The Laurel Theater and the Laurel Luncheonette, when mentioned to those who spent their teen years in the city, bring forth gushes of nostalgia. Rickey and Hy Pine are no longer there, but the luncheonette continues to be a favorite spot for oldsters and youngsters alike. The theater lives on only in memory for its up-to-the-minute movies and live performances and for many as the site of their high school graduation. (Courtesy of Dr. Kenneth S. Tydings.)

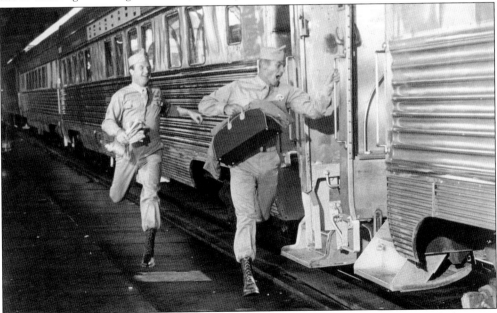

Long Beach has often been a desirable locale for filmmakers. The 1959 movie *That Kind of Woman*, directed by Sidney Lumet, starred Sophia Loren and Tab Hunter in scenes filmed at the Long Beach train station. In action familiar to many a commuter, Tab Hunter, clutching a duffel bag, is seen here running to catch the train. During the filming, Sophia charmed West Enders when she dined at Paddy's Italian Restaurant.

In 1927, the Lions Club sponsored the New York Athletic Club's 26-mile marathon from New York City to Long Beach City Hall. That set the precedent, and for the last 40 plus years the Long Beach Recreation Department has joined with the Lions to organize running events on the most natural finishing line venue, the boardwalk. The 5-miler is a Labor Day event with prizes and awards donated by local merchants. (Courtesy of Flo Hausman.)

Annually on Super Bowl Sunday, thousands of thrill seekers plunge into Long Beach's icy Atlantic waters. Cheering on the beach and boardwalk are more than 10,000 spectators. The event is organized by the Long Beach Polar Bear Club to benefit the Make-A-Wish Foundation. Founders Kevin McCarthy and Pete Meyers plunged into the waters as a lark and in 2000 formally organized the event that has raised donations of over $2 million for the foundation. (Courtesy of City of Long Beach Public Relations Department.)

The Reverend Jesse Evans founded the Christian Light Baptist Church. Despite the loss through fire of two sons along with his home, he perservered. His good works brought Coretta Scott King to place the cornerstone of his church. He was honored by the entire community in 2003 when Park Place was renamed Rev. Jesse Evans Boulevard. With the church as background are members of the Evans family, the congregation, and city council. (Courtesy of Jessie Evans Wilson.)

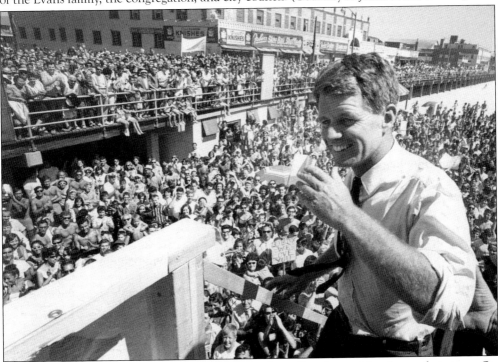

Politicians have found that, as a campaign stop, Long Beach provides the perfect stage. On September 6, 1964, Robert Kennedy, seeking election as New York senator, greeted a Long Beach crowd, reported as 6,000 strong, gathered on the boardwalk and beach. What was not reported was whether he ate an Izzy's cherry cheese knish. Kennedy won the election and served as senator until he was assassinated just after midnight on June 5, 1968, after winning the California presidential primary.

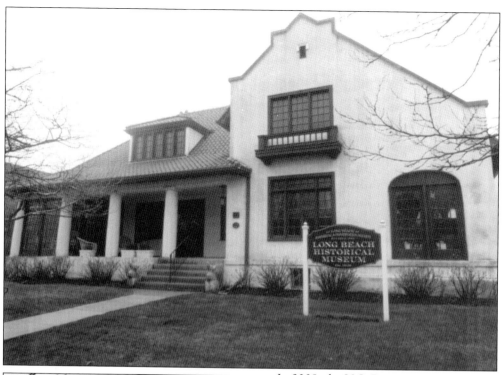

In 2008, the U.S. Department of the Interior listed the Long Beach Historical Museum on the National Register of Historic Places. The second floor of this Craftsman-style museum houses thousands of archived materials related to Long Beach history. The decor of the first floor rooms is original in the style of the American Arts and Crafts movement. Visitors are welcome to study, research, and enjoy the exhibits, lectures, and special events.

The Allegria Hotel and Spa symbolizes the ever-present Long Beach optimism that began with the building of the first hotel in 1880 and carried through the boom and bust times to the current renaissance. The beautifully appointed Allegria opened in 2009 with its restaurant fronting on the boardwalk at National Boulevard. It stands on the site of long gone Tower Baths and in more recent decades, the King David Manor.

About the
Long Beach Historical
and Preservation Society

The Long Beach Historical and Preservation Society was founded in 1980. The Society is governed by a volunteer board of trustees with a mission to educate the public about Long Beach and to preserve and enhance the city's architectural and historical heritage. The Society has been granted a permanent charter by the New York State Department of Education and U.S. Department of the Interior National Register status for its museum. As a not for profit all-volunteer organization, funds for activities are obtained through annual fundraisers, membership dues, contributions, occasional grants and museum gift shop sales.

In pursuit of its mission, the Society serves as the guardian of thousands of pieces of Long Beach history for which it maintains an archive and repository. The archived documents, pictures, artifacts and memorabilia are made available to the public through themed exhibitions, as well as for research purposes. In addition, the Society conducts docent-guided house tours and neighborhood walks to highlight the city's historic architecture. Local history tours and activities are provided for elementary school children, teachers and alumni reunion groups. The Long Beach City Historian is the Society's founder and a lifetime trustee. Along with other trustees she conducts classes and discussion groups for members and the general public. The Society publishes *Heritage*, its quarterly newsletter, to further its mission to accurately disseminate the history of its unique city. It also publishes and distributes essay brochures and pamphlets on the historical development of Long Beach.

Discover Thousands of Local History Books Featuring Millions of Vintage Images

Arcadia Publishing, the leading local history publisher in the United States, is committed to making history accessible and meaningful through publishing books that celebrate and preserve the heritage of America's people and places.

Find more books like this at
www.arcadiapublishing.com

Search for your hometown history, your old stomping grounds, and even your favorite sports team.

Consistent with our mission to preserve history on a local level, this book was printed in South Carolina on American-made paper and manufactured entirely in the United States. Products carrying the accredited Forest Stewardship Council (FSC) label are printed on 100 percent FSC-certified paper.

MADE IN THE USA